UNEX- PECTED ART

UNEXPECTED ART

SERENDIPITOUS INSTALLATIONS, SITE-SPECIFIC WORKS, AND SURPRISING INTERVENTIONS

EDITED BY JENNY MOUSSA SPRING PREFACE BY FLORENTIJN HOFMAN INTRODUCTION BY CHRISTIAN L. FROCK

CHRONICLE BOOKS
SAN FRANCISCO

Design by Matthew Rezac (matthewrezac.org)
This book has been set in Programme (optimo.ch)

10 9 8 7 6 5 4 3 2 1

Chronicle Books LLC
680 Second Street
San Francisco, CA 94107

www.chroniclebooks.com

CONTENTS

PREFACE
BY FLORENTIJN HOFMAN

You don't have to buy a ticket to a public space. It's yours. It's not like going to a theater or a museum, where you are choosing to be exposed to a type of art. It is my job as an artist, if I am allowed the use of a public space, to connect the audience to my work. You have to involve the people. The audience is not only the spectators—it is part of the art.

Recently, I visited my hometown. It's a small place, the kind of place where everyone knows one another. The neighbors were happy to see me; they've been keeping up with my career as I have become more well-known. One neighbor came up to me and said, "Do you remember, Florentijn, when you used to build scenes out of soapboxes and come around asking us to see what you had made?" As a child of six or seven, I would create little worlds, adventurescapes, fantasy lands, out of soapboxes and take them around the neighborhood asking, "Have you seen what I made?"

I always had the sense that if I was going to make art, it had to be big, and it had to touch many people. From my days as an art student, when I started a small business with two friends painting murals each summer, public artwork is what I fell into naturally. After I graduated, I continued my work with public space—I had a feel for it, a love for it.

I love the connection with people. And I love the unique challenges posed by working in a public space. There are clearly logistical considerations in work of this scope: dealing with the paperwork and the local governments, making a work "asshole-proof," as we call it in Holland; that is, protecting it from vandals. The challenges of public installations—the approvals, the safety standards—push you to be more creative. There are problems that you have to solve, issues to overcome. As a result, it becomes a collaborative process. Part of the strength of the work comes from this collaboration with the many hands that touch it.

When beginning a project, I start with a site visit. You have to take into account all of the ingredients—the history of the place, the demographics, who lives there, the buildings—everything that comes together to make the place what it is. A public space can become so familiar that a person doesn't see it anymore. People pass through a space that they've been through dozens, even hundreds, of times before, and it has become completely invisible, utterly strange, to them. When I insert a new object into that space, it provides a bright new perspective to the viewers, so that all of a sudden, they experience their surroundings once more.

Changing the volume of the space is one way to make the familiar fresh and new. The materials I use are also key to providing the unexpected—I have used flip-flops, tiles, plastic bags, thatch. If I try to astonish myself first and foremost, I can feel confident about bringing the awe factor to an installation.

Slow Slugs, in Angers, France, took many hands to complete. I worked with dozens of volunteers who tied forty thousand plastic bags to the frames forming the slugs, which crawled up the stairs to the church. Seeing this location in Angers, a stairway to a church—to God, to religion, to death—as well the way to a commercial district behind the church, brought to mind a race to the finish. The slow race of slugs up the church stairs combined with the suffocating effects of plastic bags and commercialism all came together in this public work. As with many public pieces, it was up for only a short time—days—but if I have succeeded in changing the space, providing the audience with a new perspective, then the impact has been made. And the work will live on in publications and on the Internet.

A dozen years ago, I bought a world map. I fashioned stickers in the shape of a rubber duck, and I stuck them all over the map in the hopes that one day, I would bring my *Rubber Duck* project—a giant version of the child's bath toy—to these places. Now, it's happening. The *Rubber Duck* has been to more than twenty locations in eleven countries, and the momentum is growing. It's an installation in which the audience reaction, the joy, the togetherness, is intrinsic to the experience. We all want to be amazed and astonished. The strong visual reference to a familiar object—an enormous rubber duck—draws the audience in. The scale of the *Rubber Duck* turns the harbor, bay, river into a giant bathtub and makes us all feel small. The audience becomes part of the installation, its reaction integral to the piece. You could be a CEO or a butcher, but we are all the same before this work. It interacts with all layers of society. It makes the world smaller. In my work, I play with scale. The effect of my work is to change your perception of reality.

Art doesn't always have to be difficult; you don't have to sweat to understand it. It can be a work that is all about relating, where we are all free to watch and investigate and discover. My sculptures don't change reality. They reveal what is already there and make you part of it.

INTRODUCTION
SITE-SPECIFIC INSTALLATION: SOME HISTORIC CONTEXT
BY CHRISTIAN L. FROCK

Over the past century, art has evolved from conventional studio methods, such as painting or sculpture, to include wide-ranging approaches to art making, including conceptual ideas, time-based media, performances and happenings, and many other experimental forms. Many of these shifts have resulted from expansive ideas about the location for art beyond the studio or the gallery. This awareness of how art can reflect on or challenge the conditions of our milieu has also led to the development of site-specific installation. As a style of working, site-specific installation can be generated from any discipline. Painting can be site-specific, as can sculpture, performance, or digital art. Regardless of medium, site-specificity is primarily distinguished by an intrinsic relationship to location. Site-specificity indicates that the work simply cannot exist in the same form in another space; even if the artwork could be relocated, its significance would be lost. This inseparability may stem from material constraints or from location as a basis for understanding, among other reasons, but it is also anchored in perception and, in this way, offers the possibility of uniquely intimate and unmediated transmission of the artist's intentions. This essay offers a selection of recent histories from which to consider the development of ideas around site-specific art, as well as the shifting terrain surrounding various private and public sites as critical context.

In the late 1920s, the German painter Kurt Schwitters began work on a series of installations that occupied rooms in his family home. The first work, known as *The Merzbau* (1923–1936), transformed several rooms with installations that were part collage, part sculpture, and part abstract diorama. Schwitters fled Germany for Norway in 1937. In the rare images that remain, after an Allied bombing raid destroyed *The Merzbau* in 1943, we see a room commanded by jutting angles and a fantastical, immersive stage set of three-dimensional shapes. This installation was part of a larger body of work Schwitters referred to simply as the *Merz*, which also included artists' publications, sculptures, and "sound poems"; he would also go on to create several other versions of *The Merzbau* over time. In its first iteration, *The Merzbau* developed in concert with the artist's interest in Dadaism, the European avant-garde movement that drew from visual art, poetry, theater, and design, with an emphasis on anti-bourgeois and antiwar politics. Marcel Duchamp, a pioneering Dadaist, explored these ideas with sculptures assembled from mass-produced objects. His perhaps most famous readymade, *Fountain* (1917), is a urinal signed "R. Mutt." That Schwitters would later respond to architecture as a kind of readymade is in keeping with Dada ideas about the inherent context of given forms.

Following Germany's social and economic collapse after the First World War, Schwitters spoke of the paradigm shift that necessitated

reinvention: "What I had learned at the academy was of no use to me and the useful new ideas were still unready. . . . Everything had broken down and new things had to be made out of the fragments; and this is *Merz*. It was like a revolution within me, not as it was, but as it should have been." Though site-specific installation came to greater prominence decades later with the advent of 1960s and '70s conceptual practices, *The Merzbau* is an important early example of work that considers new applications for sculpture and architecture engaged with history.

Site-specific artworks have been postmodernist phenomena, developed out of dual desires to draw attention to the larger sociopolitical context surrounding art and to challenge the marketplace for art objects. In his first New York show at John Weber Gallery, the French conceptual artist Daniel Buren presented an installation titled *Within and Beyond the Frame* (1973). It featured nineteen black-and-white striped canvases that ran across wire through the gallery, out the window to an adjacent building, and back again; in doing this, Buren complicated ideas about how to distinguish art from its location. Artists, including Buren, were also considering these questions in public spaces, often as illicit street art. Simultaneously, 1970s New York saw the rise of graffiti, increasingly as unsanctioned moving murals situated on subway trains; mobility that offered a possible antecedent to "going viral."

Just as ideas around art making are varied, so too is the dialog around site-specific artworks. A brief consideration of its vocabulary should foreground the works discussed here. Site refers to the location. It encompasses all manner of specific physical details, including depth, length, weight, height, shape, walls, and temperature, as well as geographic attributes. Locations are also embedded with social histories, civic and private, and these are often influential factors in the development of site-specific works. Some scholars prefer the term "locational," and still others, "site-sensitive."

The development of site-specific artworks in the late 1960s and early 1970s also overlaps with Land Art. Across the spectrum of possibilities, artists were questioning the boundaries of where art could exist, if not on a wall or in a gallery. No one artist is credited with solely propelling these ideas; there were several artists tackling the same ideas around the same time, far more than can be discussed here. A landmark exhibition titled *Earthworks* at Dwan Gallery in New York surveyed work by Michael Heizer, Dennis Oppenheim, Robert Smithson, and Robert Morris in 1968. Each of these artists was known to create elaborate reconsiderations of the land, as were several other artists working at the time, including Nancy Holt and Walter De Maria. Robert Smithson's *Spiral Jetty* (1970), situated in Utah, and several works by Walter De Maria, including *The Lightning Field* (1977) in

New Mexico, are maintained to this day by the Dia Art Foundation.

Similar to Land Art are Environmental Art, Earth Art, and Earthworks. The British sculptor, photographer, and environmentalist Andy Goldsworthy is one of the most famous contemporary artists working in this vein, coming to prominence in the 1980s. His largely organic installations have frequently been intimate, temporary works captured with photography: autumn leaves arranged by color gradation or pine cones organized in fragile formations. Since 2008, he has created work, at the invitation of FOR-SITE Foundation, on a series of long-term, temporary, site-specific installations at the Presidio of San Francisco, a former Civil War–era military base artificially landscaped by soldiers in the 1880s.

With the advent of Land Art in the 1970s, many artists were making work for interior spaces as well. Inspired by his mural canvases, Mark Rothko's site-specific environment *Chapel* (1971) debuted in a nondenominational chapel, known simply as Rothko Chapel, in Houston, Texas, that was privately founded by the philanthropists John and Dominique de Menil. Womanhouse Los Angeles, a feminist art installation and performance space organized by artists Judy Chicago and Miriam Schapiro in 1972, featured numerous site-specific installations, including Faith Wilding's *Womb Room* (1972). Wilding's crocheted environment challenged the male dominance of sculpture with craftwork typically associated with women. It also anticipated the present-day soft sculptural installations of the Brazilian artist Ernesto Neto, whose work offers a reconsideration of architectural space through its tactility.

In San Francisco, Lynn Hershman Leeson's *The Dante Hotel* (1972–1973) was an immersive site-specific installation in a rented room in a run-down hotel, open to visitors twenty-four hours a day. More recently, artists have responded to the context of various spaces to create work that challenges given ideologies. The American conceptual artist Fred Wilson's *Mining the Museum* (1992) at the Maryland Historical Society reorganized museum holdings to reconsider regional Native and African American histories. The French writer, photographer, and visual artist Sophie Calle's *Appointment* (1999), an intervention at the Freud Museum London, blended reality and fiction through the considered placement of objects imbued with intimacy amid Freud's family home: a woman's bathrobe draped over a chair or gloves left on the table.

Intrinsic to these ideas is the notion that site-specificity indicates that the work is created for one location—in theory, the work cannot be relocated without destroying its integrity. The most famous controversy surrounding these ideas was the removal of Richard Serra's site-specific sculpture *Tilted Arc* (1981), originally commissioned by the United States General Services Administration Arts-in-Architecture program for Foley Federal Plaza in Manhattan. The sculpture was 120 feet long, 12 feet high, and nearly 3 inches thick, and it essentially bisected the plaza. The art historian, feminist, and urban theorist Rosalyn Deutsche has indicated that this site-specific installation developed out of the desire to "interrupt, rather than secure, the seeming coherence and closure" of certain spaces. Though *Tilted Arc* successfully disrupted its location, this did not endear it to the public. After much heated debate, it was removed overnight in 1989. Serra, from the onset of these debates, stated that removal effectively destroyed the work and that it should never again be exhibited, in any other situation, ever. It remains in storage in limbo—a government-owned seventy three-ton site-specific former artwork whose status as an artwork was revoked by the artist after its removal from its intended site.

Following this debacle, public funding for site-specific public artworks has receded precipitously over the years, as has an interest in permanent public works. More often than not, today public site-specific artworks are privately funded and temporarily situated, sidestepping both bureaucracy and public opinion. In 1993, the private nonprofit arts organization Artangel commissioned the British sculptor Rachel Whiteread to cast a life-sized Victorian home in a neighborhood on the verge of

redevelopment—though its impermanence was planned, many enthusiasts unsuccessfully rallied to preserve it. Contrasting the debates around *Tilted Arc* and *House* presents radical differences in how site-specific public art was approached and received in different circumstances.

Conversely, some of the most elegant site-specific installations have been completely immaterial and fleeting, and yet profoundly impactful. The most widely recognized example is *Tribute in Light* (2002), jointly created by the architects John Bennett and Gustavo Bonevardi of PROUN Space Studio, the artists Julian LaVerdiere and Paul Myoda, the architect Richard Nash Gould, and the lighting designer Paul Marantz, which features two shafts of light projected skyward six months after the 9/11 attacks at the World Trade Center. Initially jointly produced by the Municipal Arts Society of New York and the nonprofit arts presenter Creative Time, it is now produced annually by the Municipal Arts Society each anniversary. Its favorable impact on cultural memory is a testament to its success as a site-specific public artwork and monument. Visible from some sixty miles away, its expansive visibility to a local audience and its photogenic qualities in globalized digital media created a strong sense of recognition and ownership across a global audience. This work surely finds its origins in a broad number of artists who experimented with altering our sense of place with light alone. The so-called Light and Space artists, including Robert Irwin, Doug Wheeler, and James Turrell, among others, began experimenting with light projections in the 1960s. Over the decades, Turrell's work with light and visual phenomena has been expansive—his magnum opus Land Art environment, *Roden Crater*, a "naked eye observatory" near Arizona's Painted Desert, has been under construction since 1979.

Site-specific artworks evolved as a way for artists to address shifting politics and to assert autonomy within challenging conditions. The impetus has not changed; even when a work is seemingly void of overt politics and appears to be merely beautiful or perhaps pleasurable, the larger conditions of its production are political. In the 1920s, Kurt Schwitters was making work in response to his era; even when the work itself was absent of recognizable images, it was inherent to the conditions of its existence. In the 1960s and '70s, when site-specific installation became more common practice, artists were responding to a wide range of concerns, including identity politics and the environment, among a host of other matters. As time has passed, the ideas at the genesis for site-specific art have continued to accrue: In addition to historical concerns, artists today wrestle with the shifting private and public dynamics of contemporary life, globalized audiences, and digital enterprise. Site-specific installations shift our perceptions about the world around us, creating unfamiliar terrain in our everyday surroundings while forcing a reconsideration of history in light of the present day. In this regard, the artworks featured in this book become intrinsic to the legacy of a given site and embedded in cultural memory, shifting our perceptions, sometimes even long after they are gone.

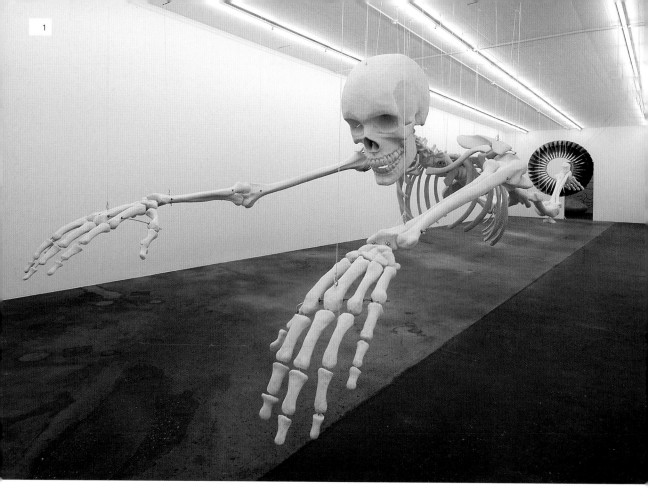

ADEL ABDESSEMED

***Habibi*, 2003**
Geneva, Switzerland
Resin, fiberglass, polystyrene, and airplane
engine turbine
Overall length: 21 m (69')
© Adel Abdessemed, ADAGP Paris
Courtesy the artist and David Zwirner, New
York/London

Installation view of *Habibi* (2003) at the
2004 solo exhibition *Adel Abdessemed: Le
Citron et le Lait* at the Musée d'art moderne
et contemporain (MAMCO), Geneva,
Switzerland

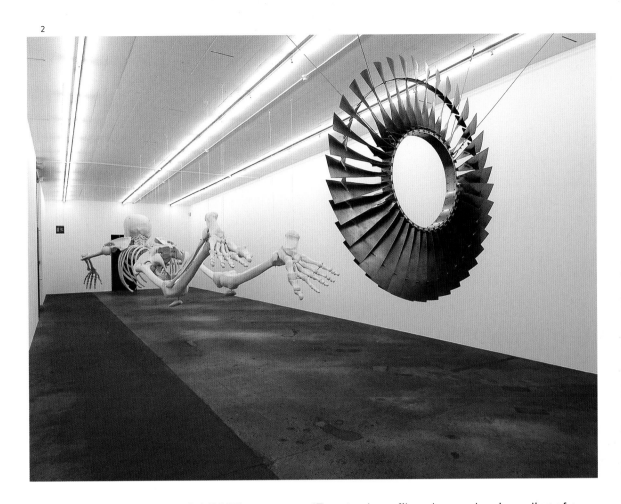

Habibi (2003) presents a 17-meter-long fiberglass and resin replica of a human skeleton. Suspended from the ceiling alongside a large-scale airplane engine turbine, it hangs horizontally by thin cables and wires. This piece is related to a later work by the artist, *Habibti* (2006), which depicts another skeleton suspended from a ceiling scaled to the size of Abdessemed's wife. In both works, the figures seem to levitate as the wires hold them in a prone position, calling to mind the strings of a puppeteer's marionette. Whereas the smaller skeleton is made from murano glass and flanked by locks of dark hair, *Habibi* is executed at a 10:1 scale and cuts an exuberant figure in space, almost flaunting its strength, rather than exposing vulnerability.

Text courtesy David Zwirner, New York/London

TANYA AGUIÑIGA

1

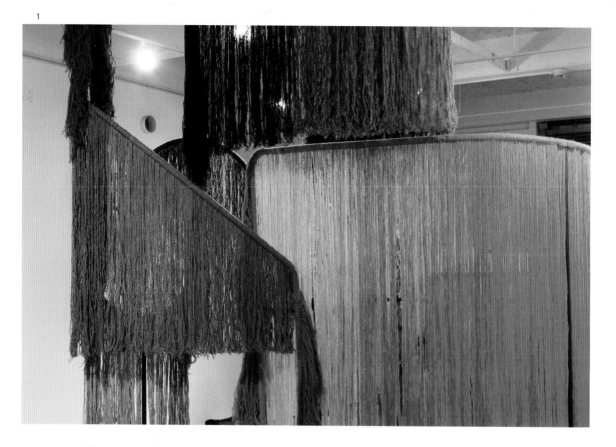

1–2
Kasthall Shag Curves, 2013
Steel and wool yarn

The intent of this piece was to highlight Kasthall's amazing range of yarn for its trade booth using a bent, tubular steel structure that packs flat for easy transport. Each connection point on the structure allows for the piece to pivot, providing multiple uses. The piece can function as both a partition and in a condensed version where the audience enters the piece and has a more intimate interaction with it. The heights of the piece varied from 6 to 12 feet, with the tall sections giving the Kasthall booth more visibility from afar, and the lower heights providing cozy areas for photo opportunities (and viral exposure). The piece is strung using Kasthall's yarns and employs the same attachment techniques used in its yarn color cards.

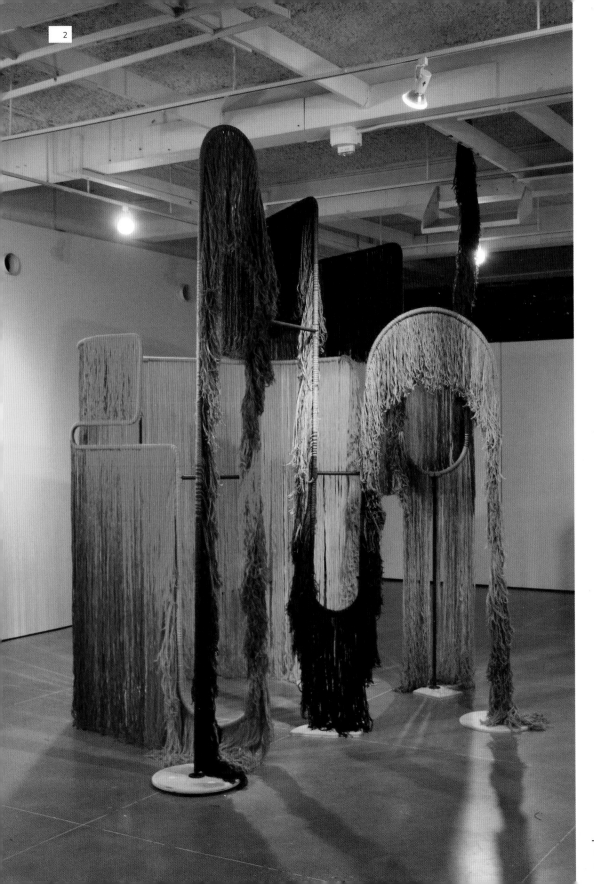

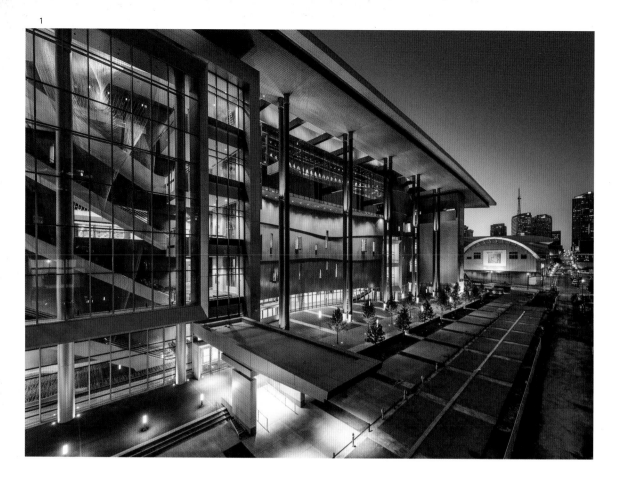

BALL-NOGUES STUDIO

1–4
***Euphony*, 2013**
Music City Center, Nashville, T.N.
Stainless steel ball chain, steel tube,
baked enamel finish
106' × 8' × 36', 3,500 lbs

Catenary stainless steel ball chains descend dramatically from a suspended elliptical ring beam and then return skyward on a new path, forming two shells of pattern and color. We produced a translucent three-dimensional painting, fabricated with a custom digital cutting machine. Depending on the viewer's vantage point, the 1,141 multicolored chains of *Euphony* may appear as a hard-edged geometric form or blur to a vapor-like visual composition. *Euphony* amplifies aesthetics of light, reflection, and color, creating a visual spectacle and physical sensation in a public space. Twenty-five miles of stainless steel chain are attached to a 30-by-8-foot steel ring beam that is suspended 3 feet from the ceiling.

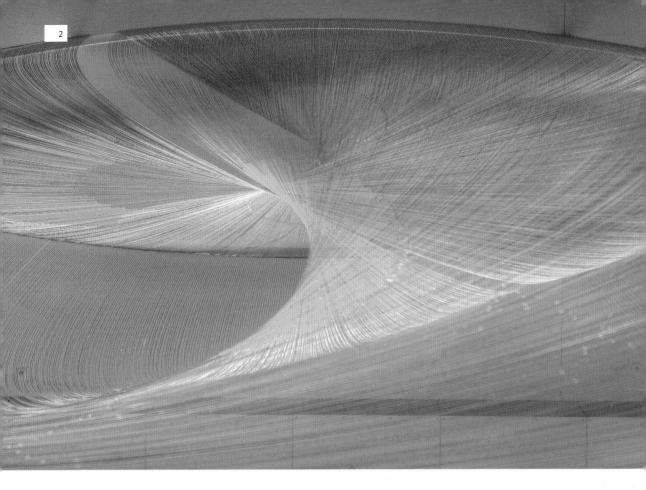

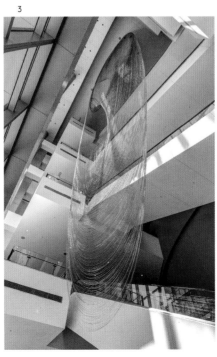

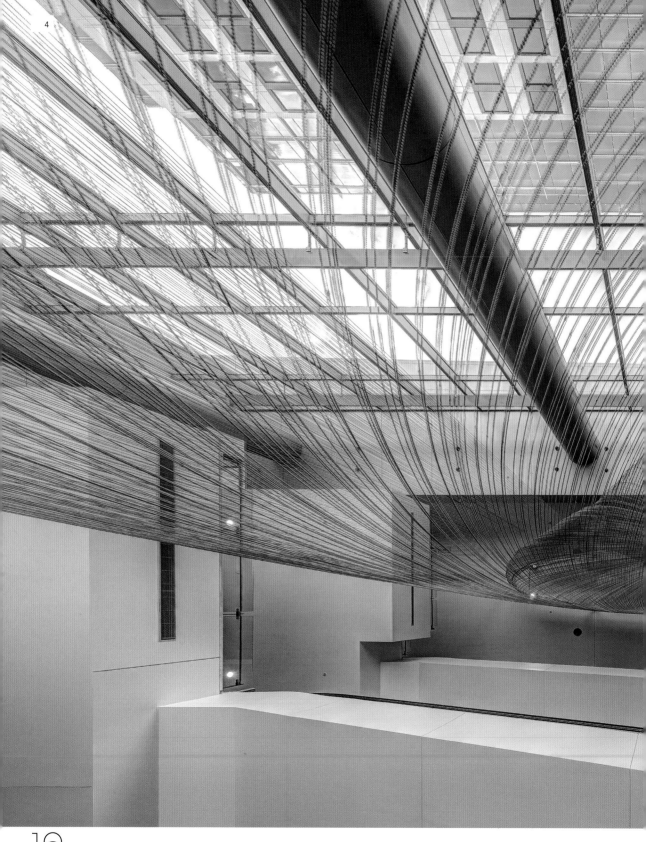

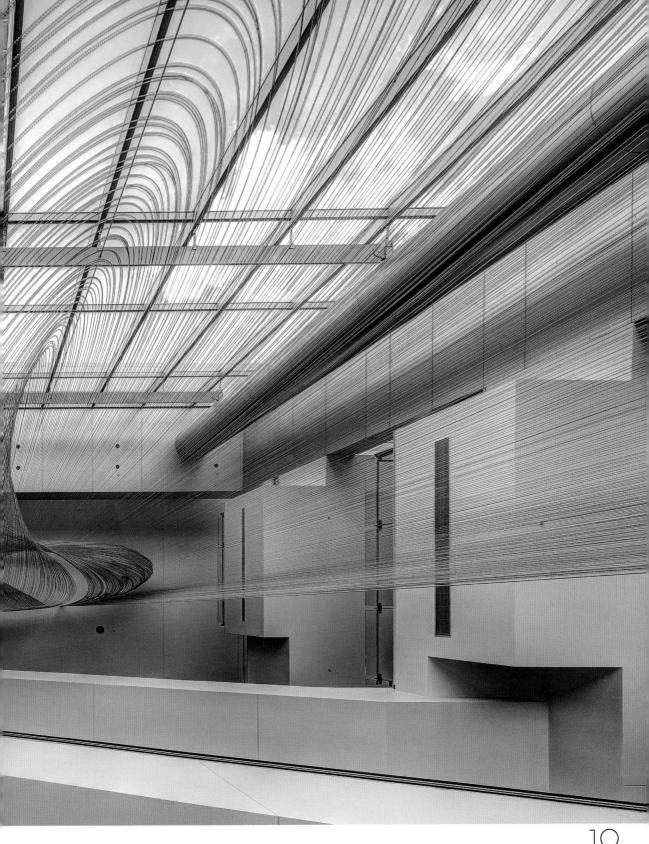

ROBERT BARTA

1–4
Crossing Half a Million Stars, 2011
8-mm metal ball bearings, approx.
500,000 pieces

In this installation, *Crossing Half a Million Stars*, which consists of roughly half a million ball bearings covering the entire floor, visitors are invited to use the exhibition space. To be able to walk on this surface without slipping and falling takes extreme care. The installation creates an ongoing performance shared by all present—a collective entertainment that forces visitors to focus in a different way on themselves and on one another. In *Crossing Half a Million Stars,* the piece becomes the gallery space, and the visitor becomes the object of desire.

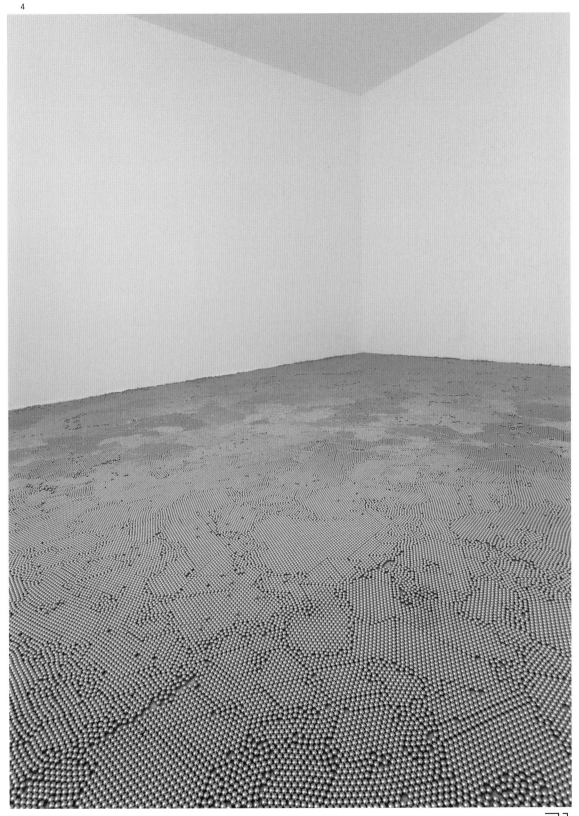

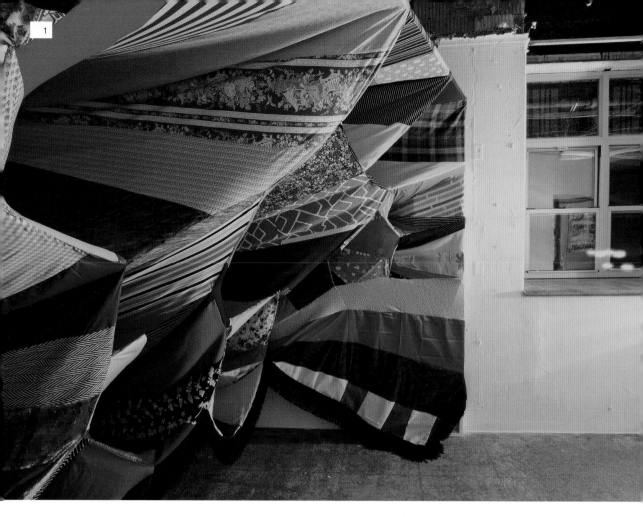

AMANDA BROWDER

1–3
Prismatic Vortex, 2012
Brooklyn, N.Y.
Donated fabric, wood, rope

Prismatic Vortex was constructed in the lower level of the St. Nicks Alliance in Brooklyn, N.Y., at the Arts@Renaissance residency. The building, originally an outpatient facility of Greenpoint Hospital, and the installation, fabricated by volunteers from the neighborhood, came together to redefine the structure while entangling the community in the mystique of fine-art creation. The social goal of engaging volunteers in large projects is to bond individuals with their neighborhoods and contemporary art. From material collection to construction and exhibition, community volunteers are encouraged to collaborate in a creative dialog about city, community, architecture, and art.

2

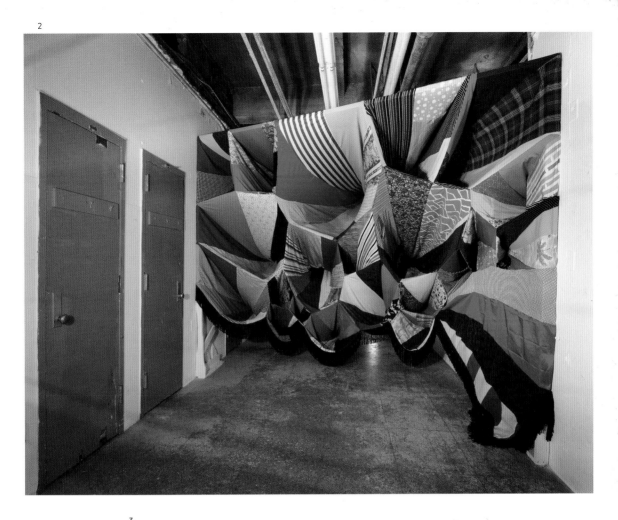

3

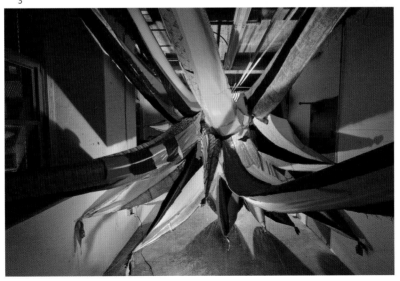

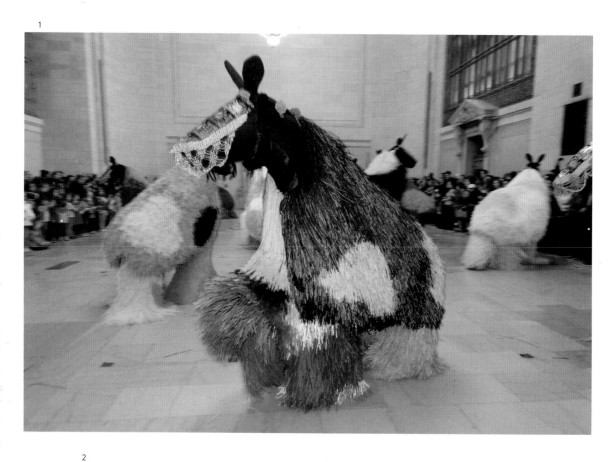

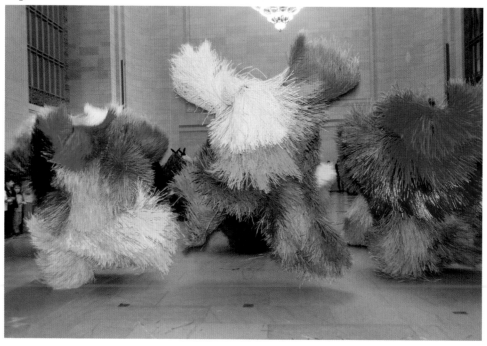

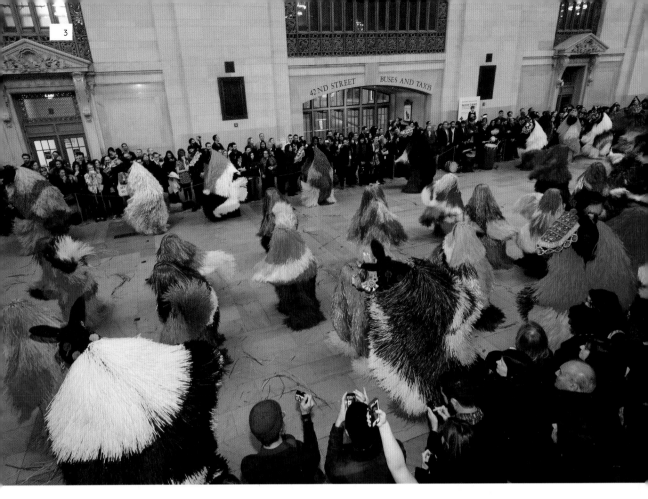

NICK CAVE

For *HEARD•NY*, Chicago-based artist Nick Cave transformed Grand Central Terminal's Vanderbilt Hall with a herd of thirty colorful life-size horses that broke into choreographed movement—or "crossings"—twice a day, accompanied by the sound of African drums and harps. Students from The Ailey School, two to a horse, brought the full-sized creatures to life through both choreographed and improvised movements. The project was presented by Creative Time and MTA Arts for Transit as part of a series of events celebrating the centennial of Grand Central.

1–4
***HEARD•NY*, March 2013**
Synthetic raffia, fabric, and metal

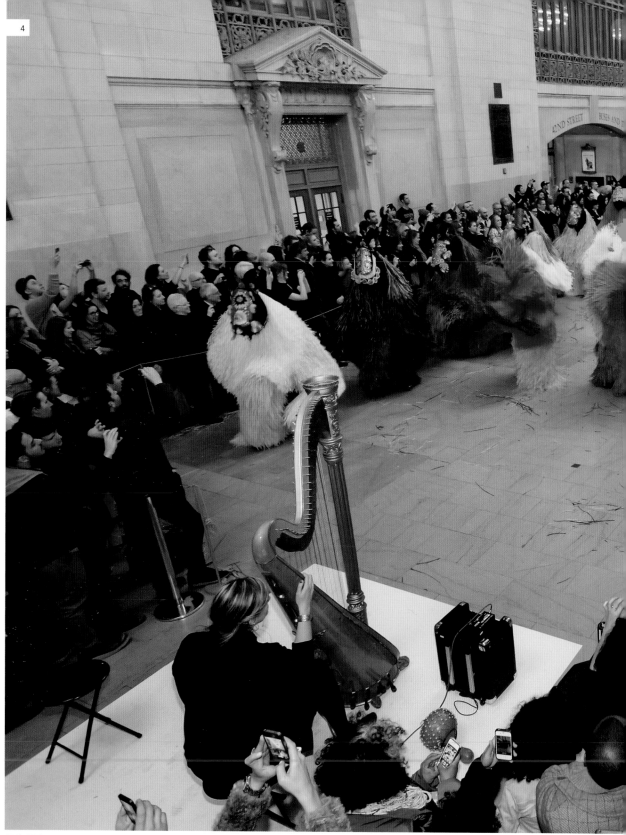

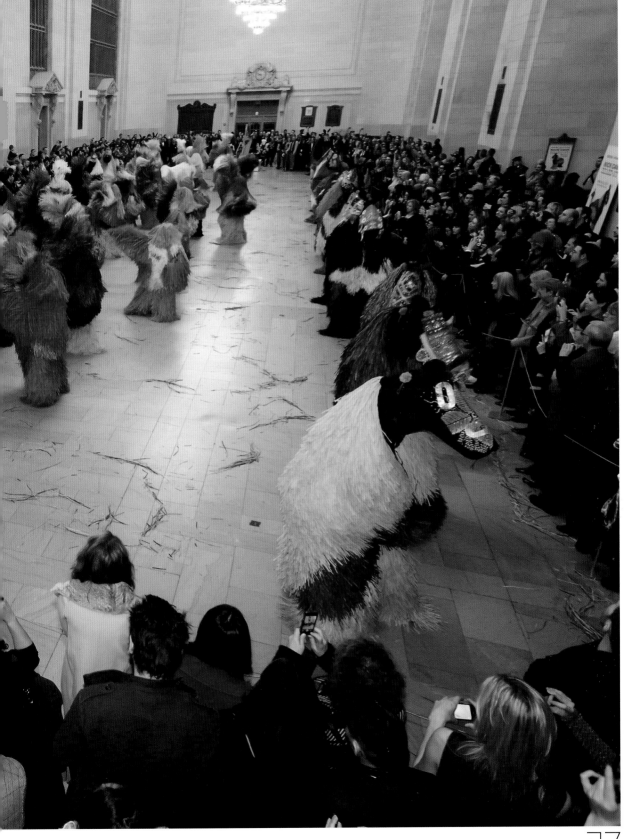

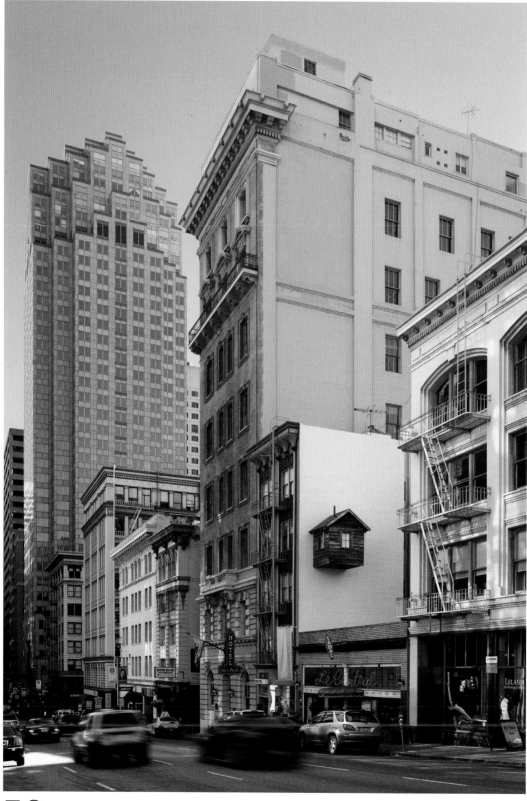

JENNY CHAPMAN
AND MARK REIGELMAN

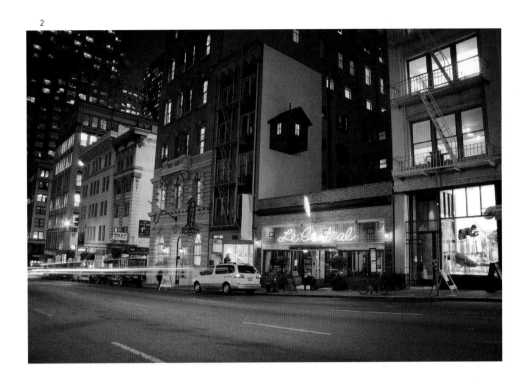

2

Manifest Destiny! is about our God-given imperative, as modern explorers, to seek out parcels of unclaimed territory and boldly establish a new home front in the forgotten urban voids of San Francisco. *Manifest Destiny!* is a rustic cabin occupying one of the last remaining unclaimed spaces of San Francisco—above and between other properties. The structure can be seen affixed to the side of the Hotel des Arts, floating above the restaurant Le Central like an anomalous outgrowth of the contemporary streetscape. Using a nineteenth-century architectural style and vintage building materials, the structure is both homage to the romantic spirit of the Western Myth and a commentary on the arrogance of the Westward expansion.

1
Manifest Destiny! / Day 3, 2012
Mixed media

2
Manifest Destiny! / Night 1, 2012
Mixed media

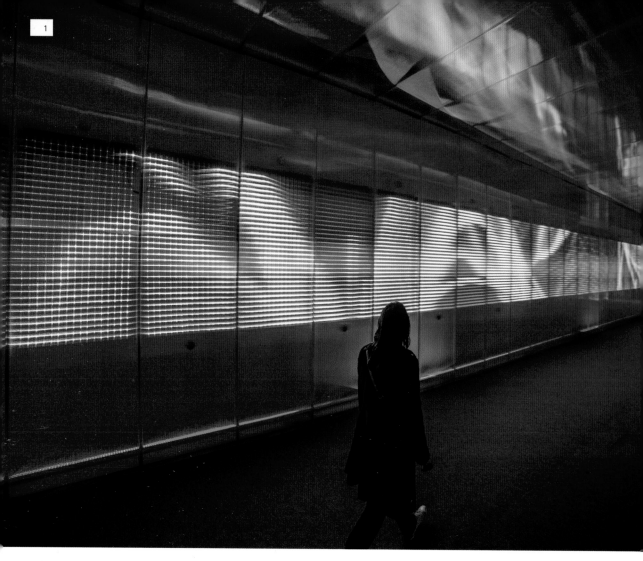

MIGUEL CHEVALIER

1–3
***Pixels Crossing*, 2012**
Generative virtual-reality
installation
Forum des Halles, Paris
In collaboration with Trafik
Music: Michel Redolfi
Software: Cyrille Henry, Trafik
Technical coordination: Voxels
Productions
Polycarbonate panels, LEDs
40 m × 4 m × 4 m

After the renovation of the Forum des Halles in Paris, Miguel Chevalier was commissioned to create a piece of art inside the temporary tunnel that connects the shopping mall with the Place Carrée. In collaboration with Trafik and composer Michel Rodolfi, he created an LED light installation along the tunnel of successive multicolored designs playing to the rhythm of Redolfi's compositions, which created a harmonic and cadenced wave pattern of sound, enriching a passer-by's sensory experience. The light diffracting within the alveolar polycarbonate wall redefined the tunnel space. It metamorphosed into a magic, contemporary passage. This installation heralded the renewal of the Forum des Halles, the heart of Paris.

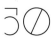

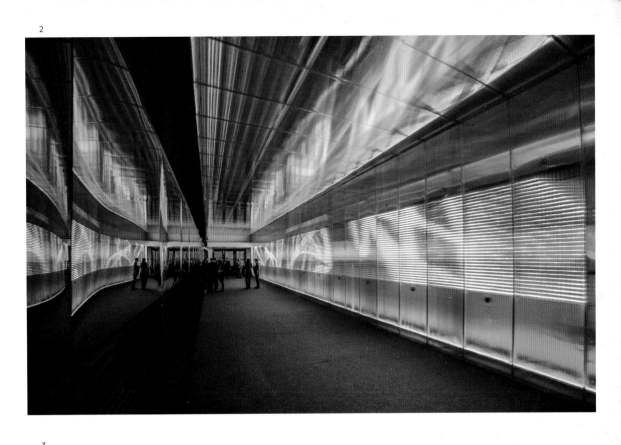

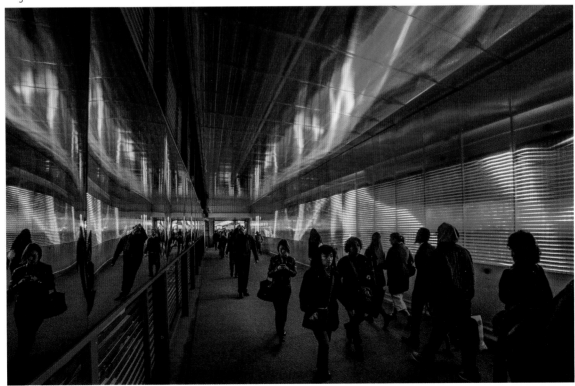

MICHEL DE BROIN

The spectacular view of the starry sky has long been a source of delight and curiosity, but the abundance of artificial light in urban areas produces a glow that covers the stars in the firmament. The largest mirrored ball ever made was suspended from a construction crane 50 meters above the ground to render the starry sky to the residents of Paris. The installation in the Jardin du Luxembourg was up for one night during the Paris "Nuit Blanche" event.

La Maîtresse de la Tour Eiffel, 2009
Paris, for Nuit Blanche
Metal structure, 1,000 mirrors, 5 light projectors, crane
7.5 m in diameter

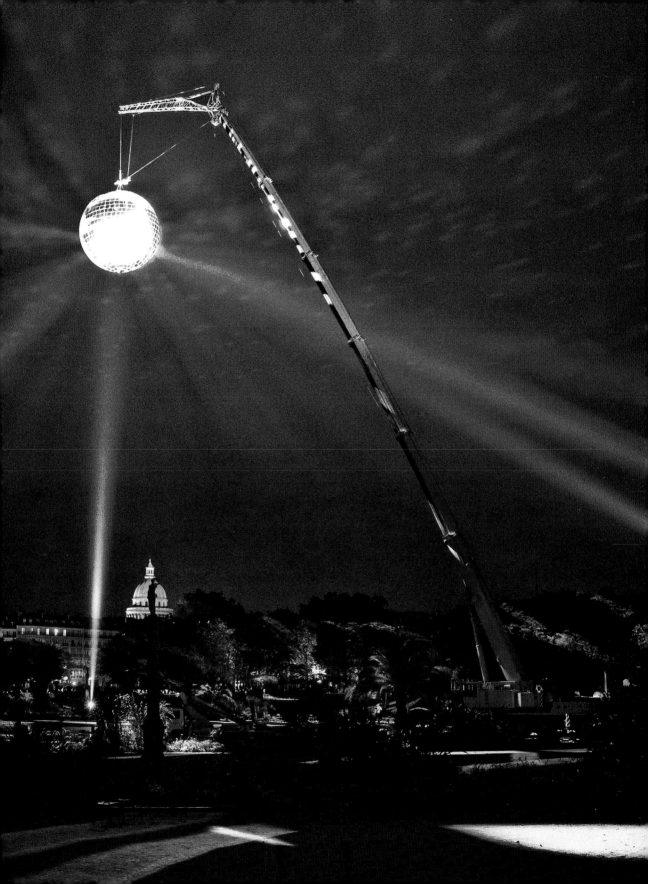

PATRICK DOUGHERTY

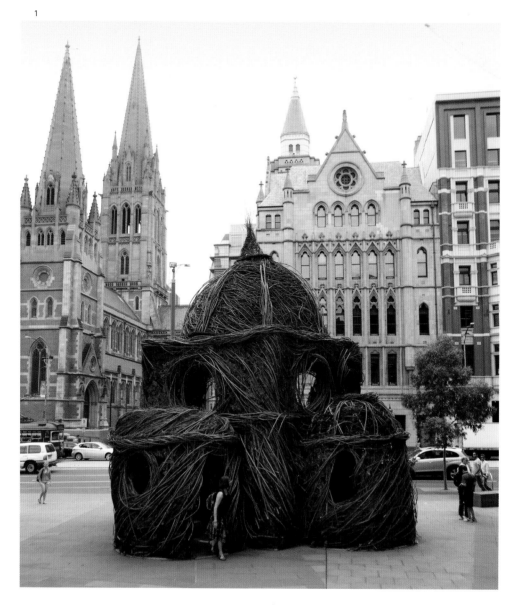

1

1–2
***Little Ballroom*, 2012**
Federation Square,
Melbourne, Australia
Willow saplings

This sculpture in downtown Melbourne, Australia, was meant to resonate with the Old World look of the train station nearby and to contrast ancient ways of building with contemporary architecture. I hoped to arrest the eye of the passerby, to spark the imaginations of the millions of people who flood into Federation Square for museum going, concerts, and dining, and to evoke a sense of nature in the midst of city bustle.

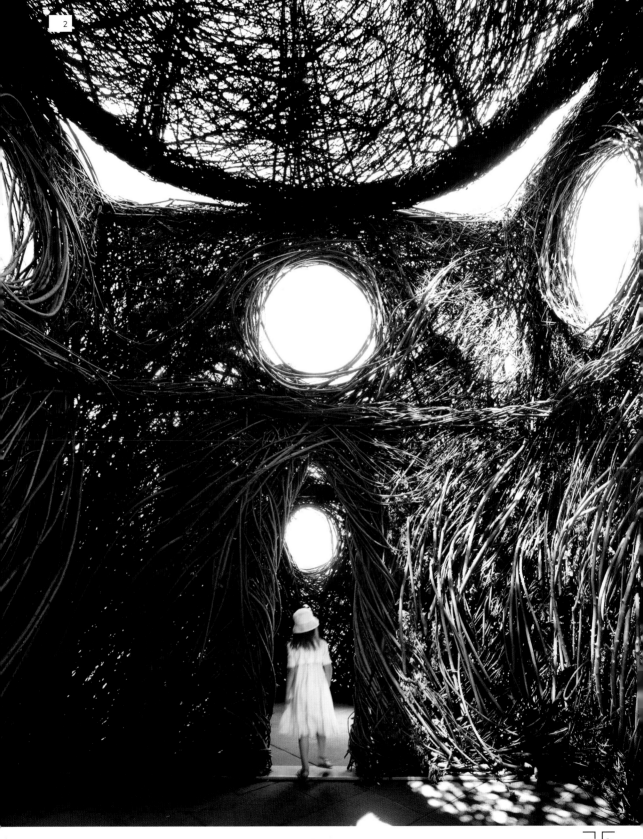

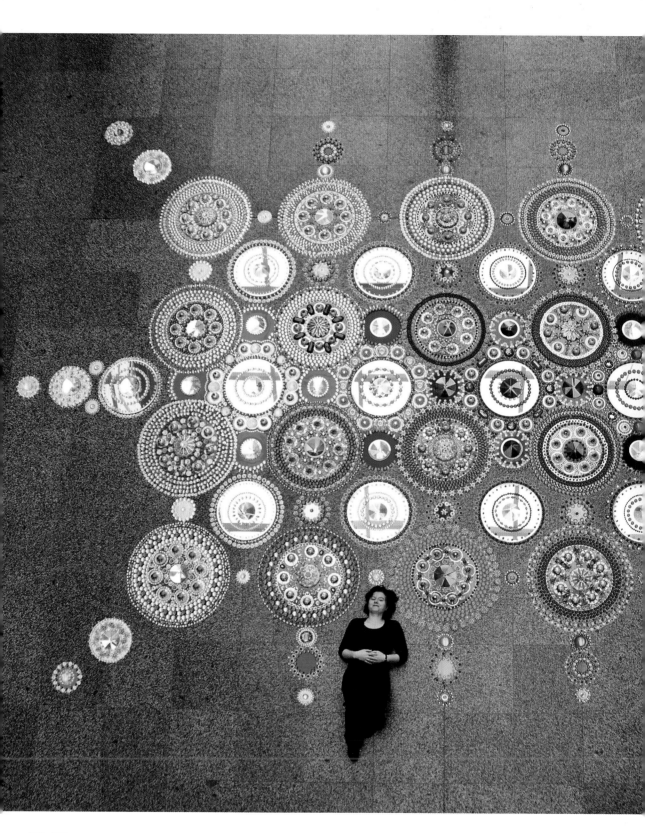

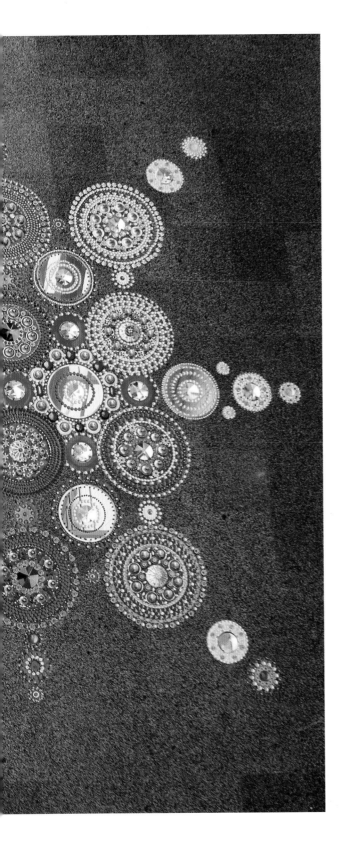

SUZAN DRUMMEN

The installation in Amstelveen, Netherlands, is made from crystal, chrome-plated metal, precious stones, mirrors, and optical glass. From a distance, the design appears clear and orderly, yet upon closer inspection, the eyes become disoriented by the many details and visual stimuli. That moment, of being able to take it all in or not, is explored, time and time again. The visual perception is challenged, requisitioned, and intensified.

2012
Sociale Verzekeringsbank, Amstelveen, Netherlands
Floor installation, several materials, mainly glass

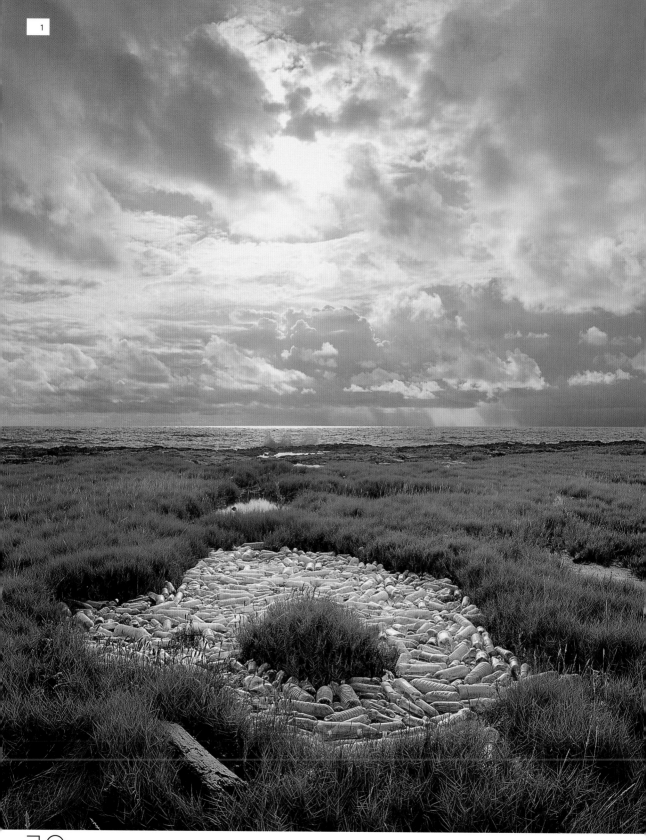

ALEJANDRO DURÁN

1
***Amanecer*, 2011, from the**
series *Washed Up*
Archival pigment print
52" × 40"

2
***Algas*, 2013, from the**
series *Washed Up*
Archival pigment print
40" × 52"

Washed Up addresses the issue of plastic pollution making its way across the ocean and onto the shores of Sian Ka'an, a UNESCO World Heritage Site and Mexico's largest federally protected reserve. Over the course of this project, Durán has identified plastic waste from fifty nations on six continents washed ashore on one stretch of coast, and he has used this international debris to create a series of color-based, site-specific installations. More than creating a surreal or fantastical landscape, these works mirror the reality of our current environmental predicament. The alchemy of *Washed Up* lies not only in converting a trashed landscape, but also in the project's potential to raise awareness and change our relationship to consumption and waste.

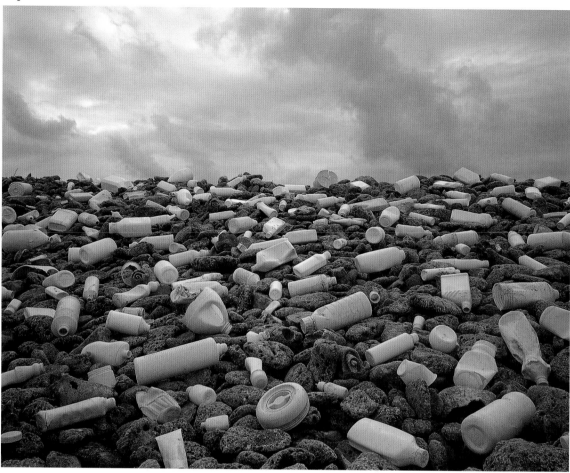

4

3
Nubes, 2011, from the
series *Washed Up*
Archival pigment print
40" × 52"

4
Mar, 2010, from the
series *Washed Up*
Archival pigment print
19" × 28"

5
Derrame, 2010, from the
series *Washed Up*
Archival pigment print
52" × 40"

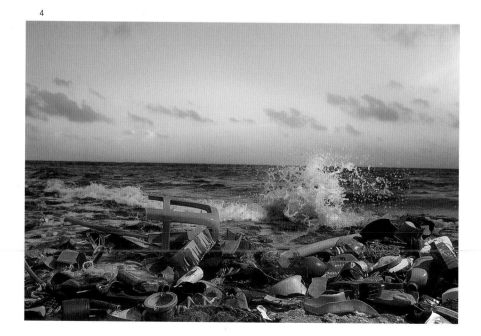

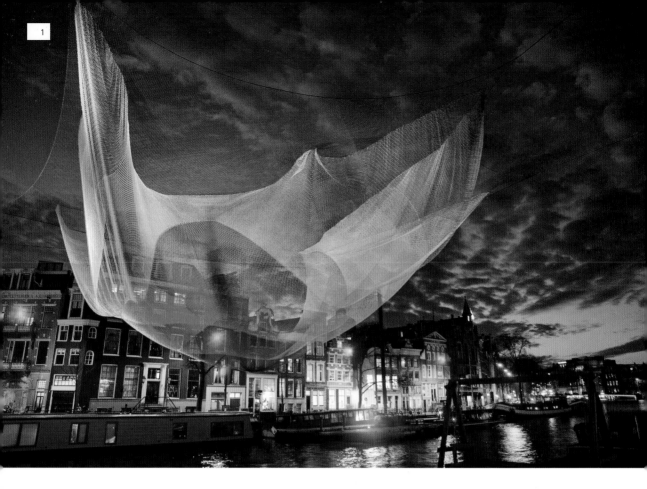

JANET ECHELMAN

1–3
1.26 Amsterdam, **2012–2013**
Spectra® fiber, high-tenacity polyester fiber, and colored lighting
Dimensions of net:
80' length × 60' width × 30' depth
Installation Dimensions:
230' length × 140' width × 30' height

1.26 Amsterdam was installed over the Amstel River from atop the Amsterdam Stopera, which houses the City Hall and Muziektheater. The sculpture is a made entirely of soft materials, which allows it to attach to existing architecture without extra reinforcement. A unique lighting program integrates undulating colors reflected on the water below. The sculpture becomes an ethereal form that transforms day to night; in darkness it appears to float in thin air.

The form and content draw inspiration from the interconnectedness of Earth's systems. The studio used laboratory data from NASA and NOAA on the effects of the 2010 Chile earthquake, and the resulting 1.26-microsecond shortening of the Earth's day. The sculpture's three-dimensional form is inspired by the mapping of tsunami wave heights across an entire ocean.

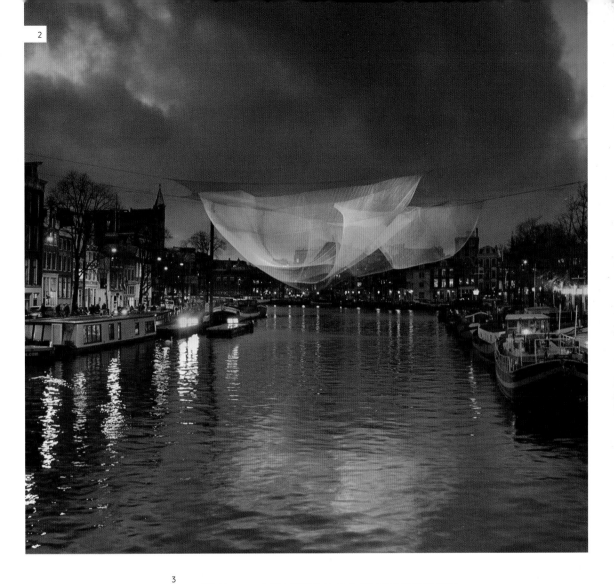

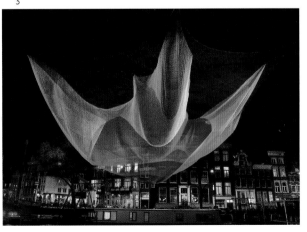

LEANDRO ERLICH

1
***Bâtiment*, 2004**
Le 104, Paris, France, 2011
Print, lights, moulding, wood, iron,
and mirror
800 cm × 600 cm × 1200 cm

2
***Shikumen*, 2013**
Shanghai International Art Festival,
Shanghai, China

Leandro Erlich's *Bâtiment* was first built in 2004 for the annual Parisian art festival Nuit Blanche, which spreads throughout the city for one night. Because so many people stroll about, the artist realized the project had to be large and accessible. He wanted it to be like a dream come true: defying the laws of gravity for a short moment. Every version of *Bâtiment* is inspired by the architecture of the area where it's placed (Paris; a small town in Japan; Buenos Aires). If art has the power to define beauty, Erlich thought that it was important for the "spect-actors" to come and interact freely with an artwork that looked like their home ground, not some ideal.

CHRISTINE FINLEY

Wallpapered Dumpsters transform environmental activism into unexpected beauty. This project is an inquiry into urban waste, free art, and notions of femininity, beauty, and domesticity. Inspired by free and accessible art the artist states, "If we see dumpsters as works of art, we have raised consciousness."

1–2
Wallpapered Dumpsters, 2010
Rome
Wallpaper and wallpaper paste

3
Wallpapered Dumpsters, 2010
Vienna
Wallpaper and wallpaper paste

4
Wallpapered Dumpsters, 2010
Santa Monica
Wallpaper and wallpaper paste

5
Wallpapered Dumpsters, 2010
Bowery and Stanton, N.Y.
Wallpaper and wallpaper paste

1

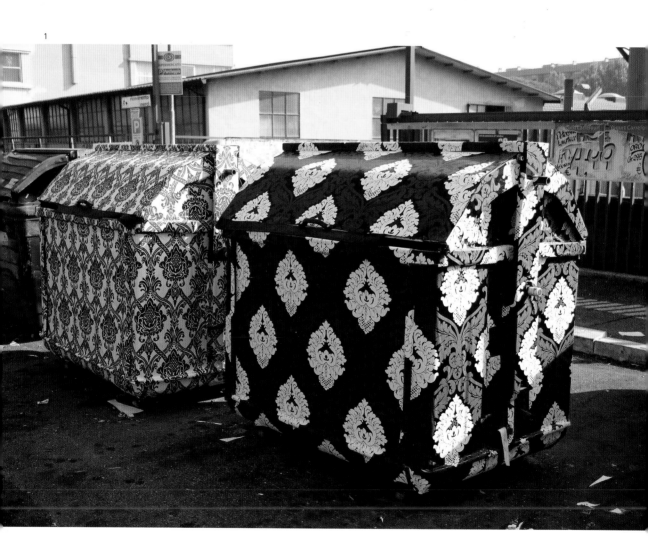

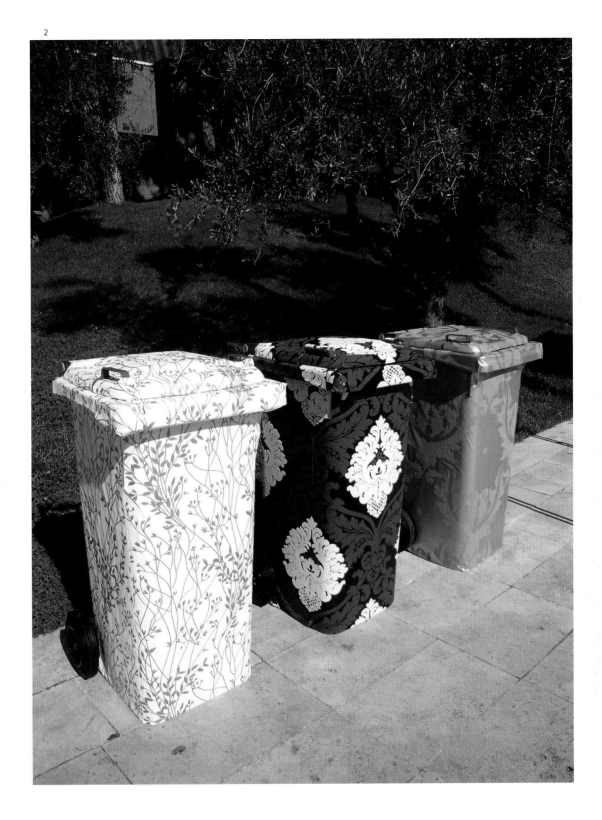

4

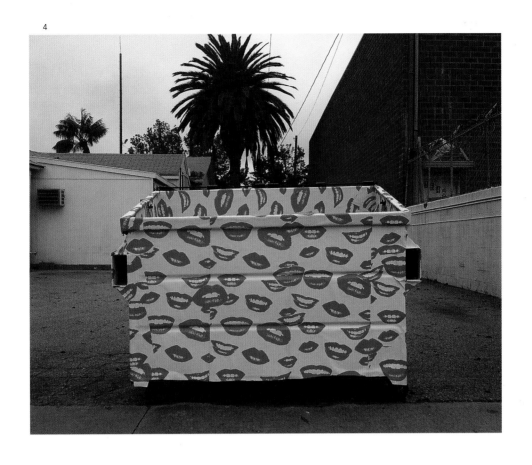

5

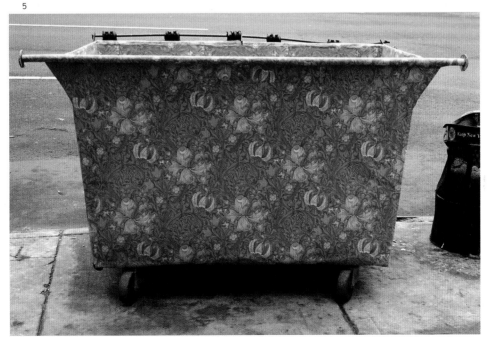

FRIENDSWITHYOU

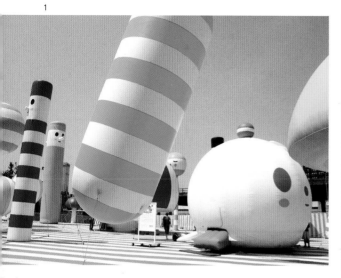

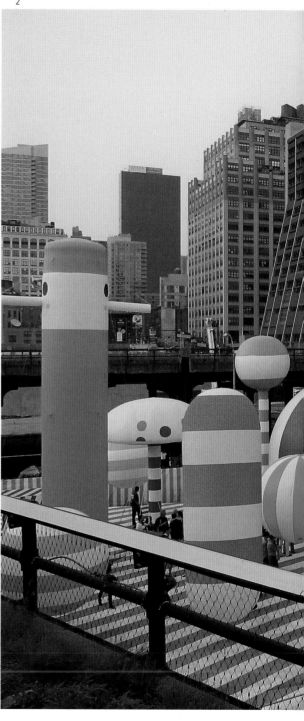

Rainbow City was exhibited in New York City in celebration of the opening of section two of the High Line Park that runs through the Chelsea gallery district. This interactive installation is a major public art installation by FriendsWithYou and was on display for an entire month blossoming from the concrete jungle, first exhibited in Toronto, Canada, and second during Art Basel Miami, Florida. It featured an exclusive pop-up shop where limited edition art products designed by FriendsWithYou for AOL were available, as was a summer-long activity zone with food and beverage venues located adjacent to the installation site.

1–2
***Rainbow City*, 2011**
New York City, N.Y.
Vinyl inflatables
Dimensions variable

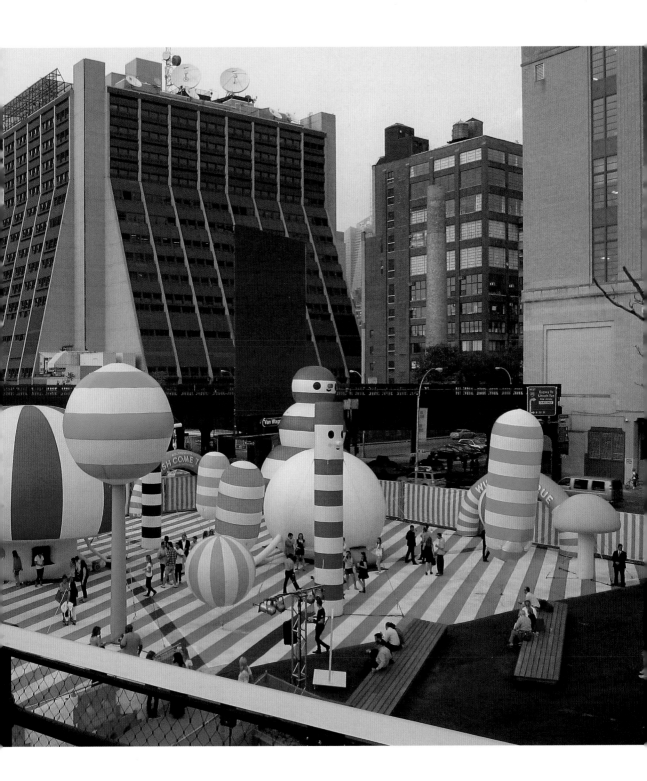

JOOST GOUDRIAAN

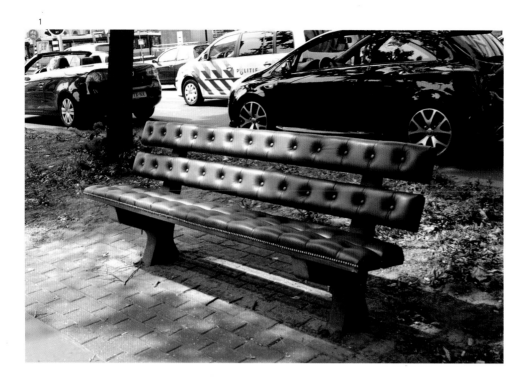

1

The public space in Rotterdam is loaded with objects, functional yet often unnoticed. The city of Rotterdam, always seeming to be desperately seeking her new "heart," supplies her many excavations with street furniture without thinking about the charisma of the street level. The sky seems to be the limit, and the eye level remains forgotten. For this project in public space, I tried to explore possibilities for the "Lovable City," master some crafts, and remake foolproof street furniture, using the original industrial designs, to investigate whether the love I've put into these objects would come out, and even might originate love for them. Foolproof? Let's see what will happen to these carefully crafted, vulnerable, upgraded and recreated, illegally placed objects . . .

1–3
Chesterfield Park Bench, 2010
Walnut, oxblood leather, concrete, steel,
polyether foam, antique wax

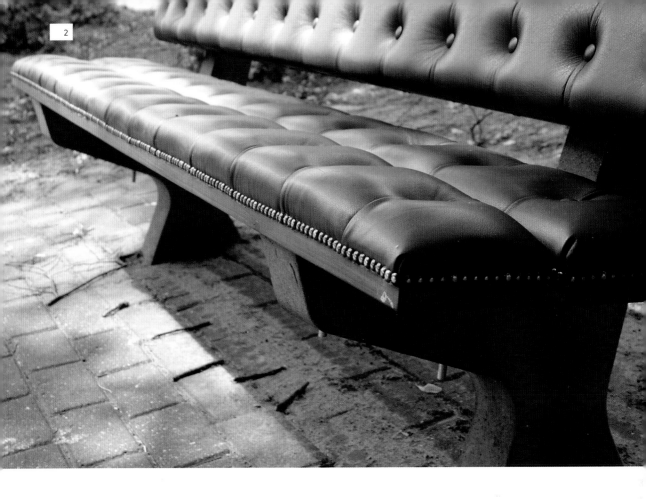

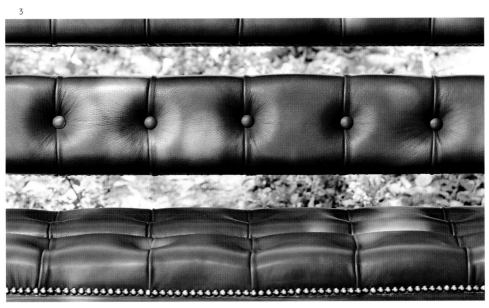

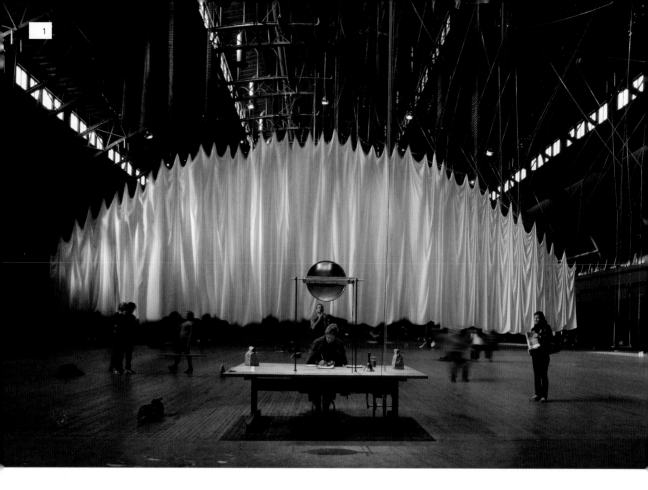

ANN
HAMILTON

1–4
***the event of a thread*, 2012**
Park Avenue Armory, N.Y.
Mixed media

Commissioned by the Park Avenue Armory for the 55,000-square-foot Wade Thompson Drill Hall, *the event of a thread* was an installation set into motion by visitors. A field of swings, a massive white cloth, a flock of homing pigeons, spoken and written texts, and transmissions of weight, sound, and silence animated the hall's space. *the event of a thread* is made from crossings of the near at hand and the far away: It is a body-crossing space, a writer's hand crossing a sheet of paper, a voice crossing a room in a paper bag, a stylus crossing a groove. It is a flock of birds and a field of swings in motion. It is a particular point in space at an instant of time.

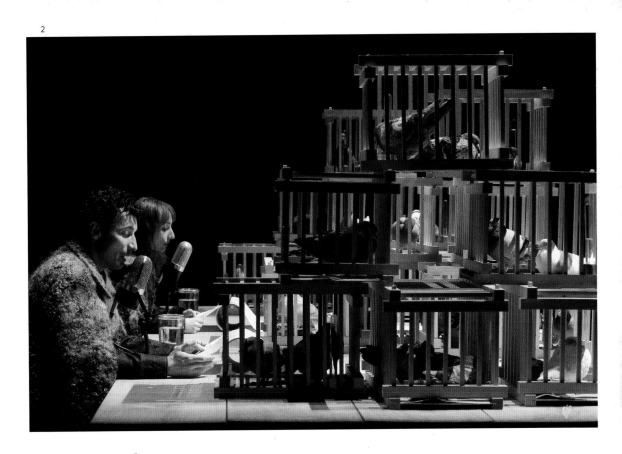

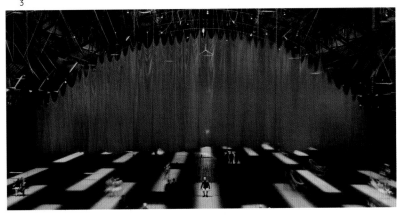

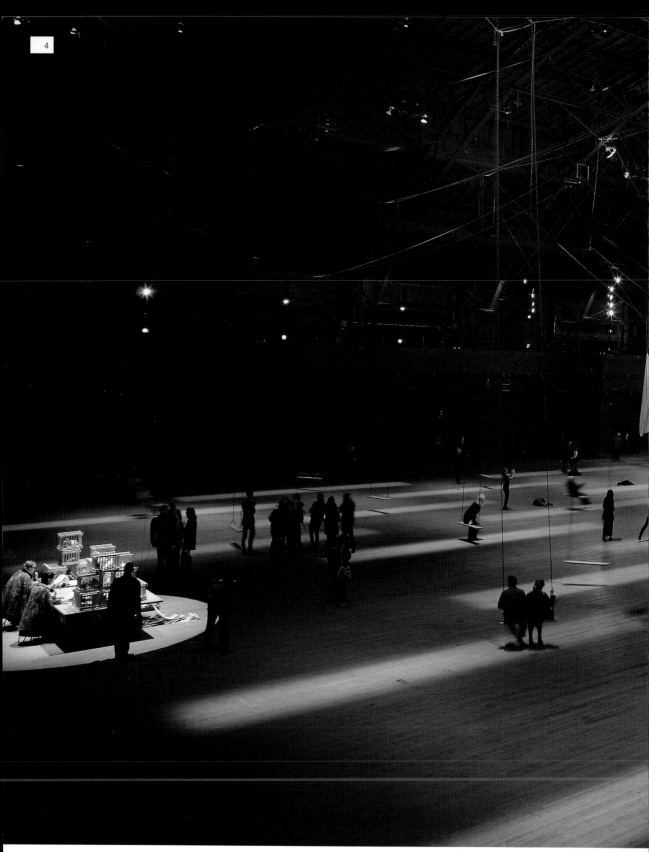

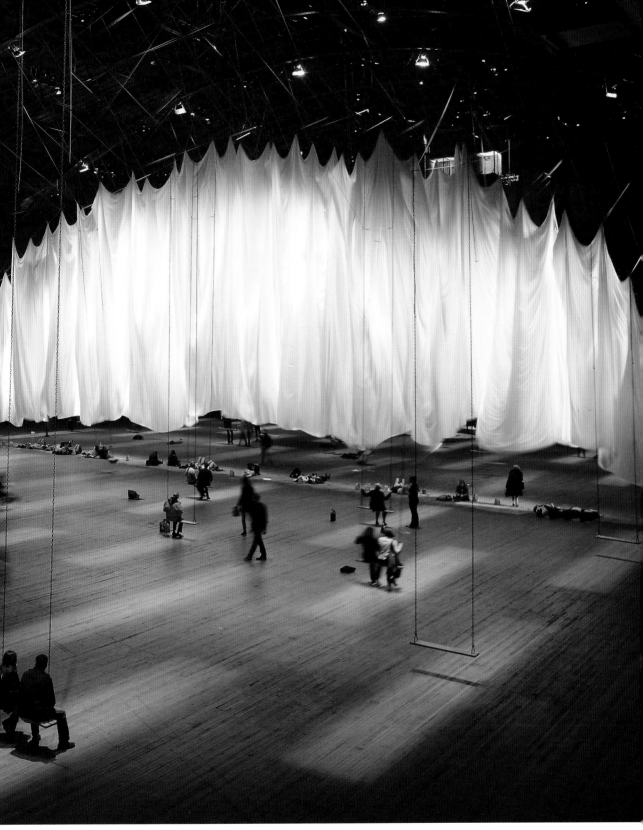

LYNNE HARLOW

1–2
515 Chalkstone, 2009
Providence, Rhode Island
Latex paint on house

515 Chalkstone is a site-specific piece that is equal parts reductive abstract painting and community engagement. The piece was made in conjunction with HousEART, a program of the Smith Hill Community Development Corporation in Providence, Rhode Island, that invited artists to make art on vacant neighborhood houses that were to be renovated and offered for rent at affordable rates. The art was temporary, communicating to local residents that the buildings were not forgotten, and remained only until the properties were transformed into quality housing.

The nature of the project challenged me to consider anew the possibilities of site-specific work. I utilized my existing reductive vocabulary to engage the neighborhood in a direct and purposeful way, and I was gratified to find that local residents responded with overwhelming enthusiasm.

1

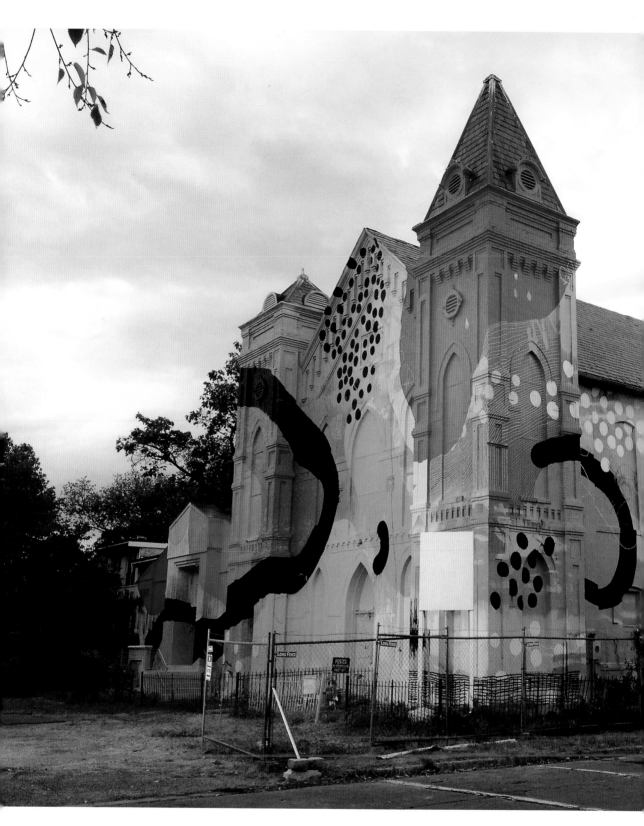

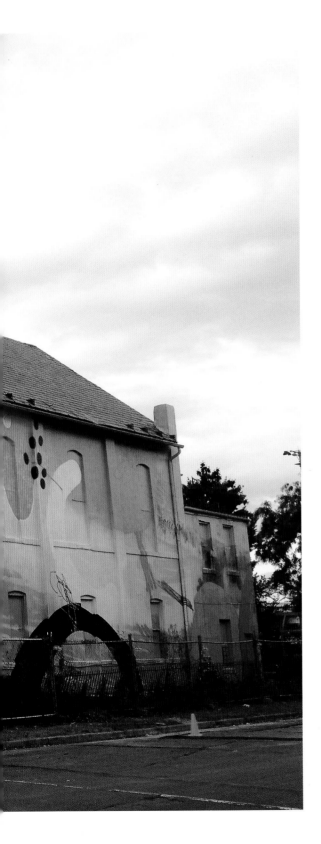

HENSE

The existing architecture dictated the direction of the painting of this church in Washington, D.C. First, we painted every surface of the building, then created the designs. The entire process took several weeks of layering. The use of bright color might be seen as irreverent, but incorporating bold colors was key to transforming the church. There were a few people who thought we were desecrating the church, but once we explained the positive intentions in the gestures, they came around. The very nature of public art is subjective. We recontextualized the church, providing new meaning to viewers. This project was the first step to bringing life and color into an area in transition, one with huge potential to be a locus for artists and art.

700 Delaware, **2012**
Washington, D.C.
Exterior latex enamel and spray
paint on building
Dimensions variable

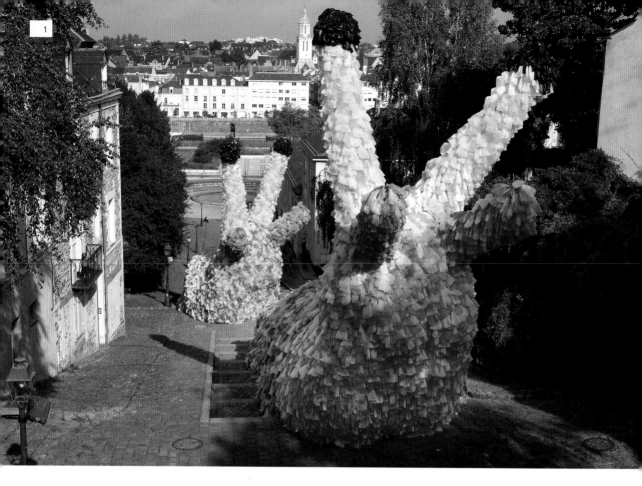

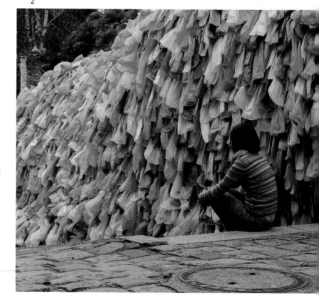

2

FLORENTIJN HOFMAN

The work is made out of forty thousand plastic bags that move in the wind. The slugs are ascending this steep city staircase that leads up to a huge Catholic church, essentially signifying their slow crawl toward death. The work reminds us of religion, mortality, natural decay, and the slow suffocation of commercialized societies.

1–3
Slow Slugs, 2012
Angers, France
Metal, football nets, and 40,000 plastic bags
Two pieces 18 m × 7.5 m × 5 m

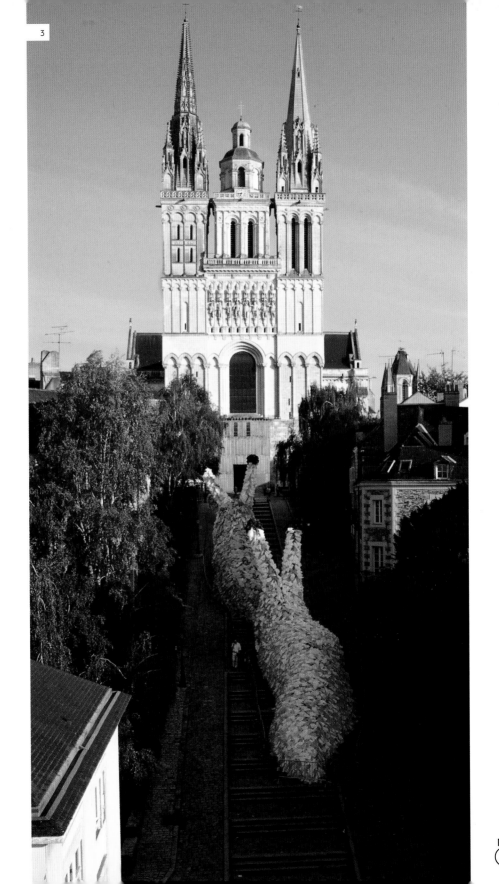

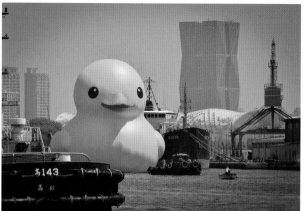

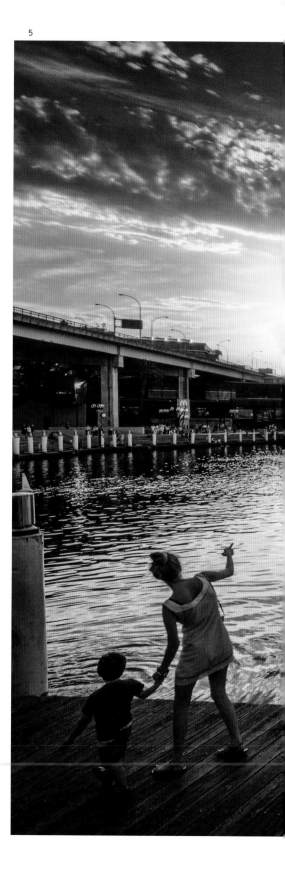

Rubber Duck knows no frontiers. It doesn't discriminate or practice politics. The friendly, floating *Rubber Duck* has healing properties: It both elucidates and relieves existential tensions. It is an inflatable, based on the standard rubber duck model that children from all four corners of the world are familiar with. The impressive rubber duck travels the world and pops up in many different cities: from Auckland and São Paulo to Osaka. It offers a positive artistic statement that immediately connects people to their childhood.

4 & 6
Rubber Duck, 2013
Kaohsiung, Taiwan
Inflatable, pontoon, and generator
18 m × 18 m × 21 m

5
Rubber Duck, 2013
Sydney, Australia
Inflatable, pontoon, and generator
18 m × 18 m × 21 m

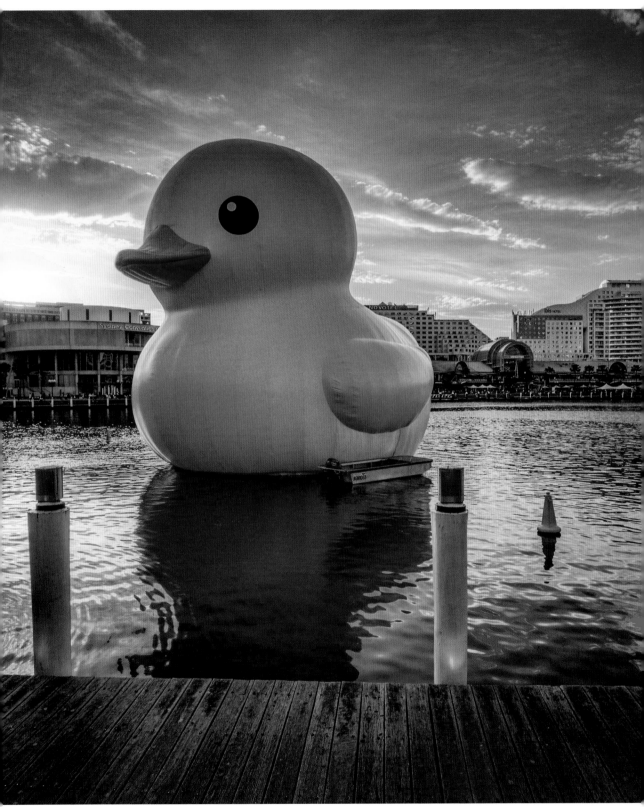

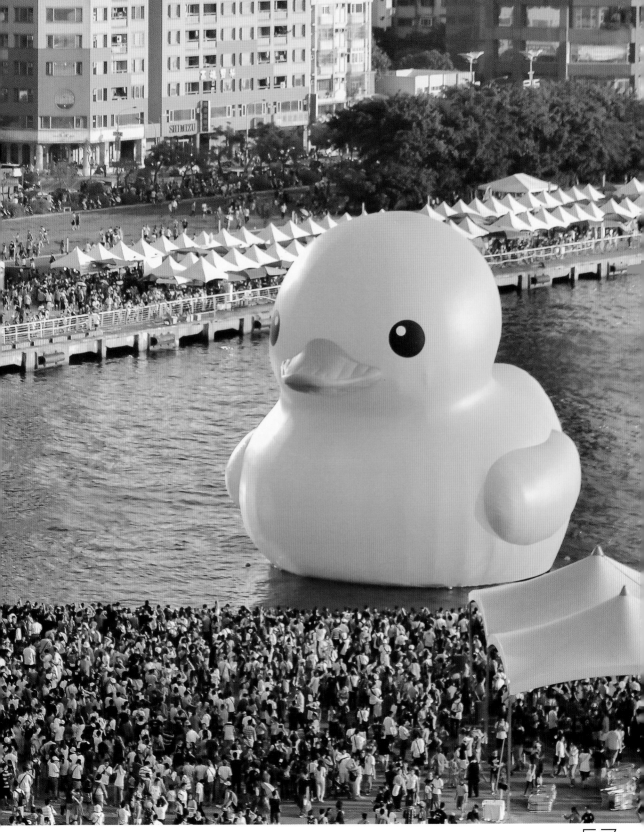

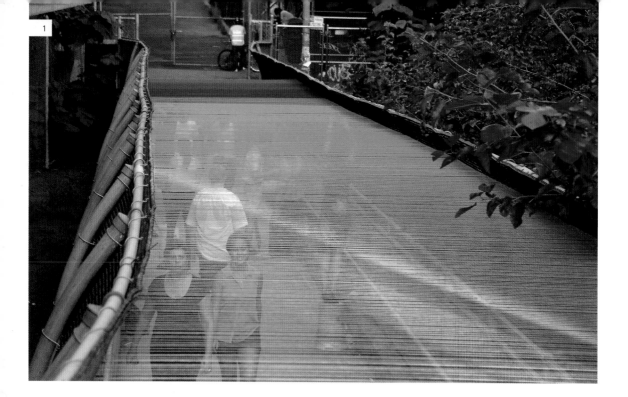

HOTTEA

In a world in which face-to-face communication is becoming less and less, I wanted to create a platform for verbal communication among people in the fast-paced environment of New York City. The Williamsburg Bridge pedestrian walking path is used by thousands of people each day. Walking across the bridge each night while I was staying in Brooklyn, I noticed that people tended to stick to themselves. I wanted this piece to slow people down, to create dialogue among one another, to spark the imagination within us all, and to create a piece that can only exist within the architecture of the Williamsburg Bridge.

1–4
Rituals, **2013**
Williamsburg Bridge, N.Y.
Yarn

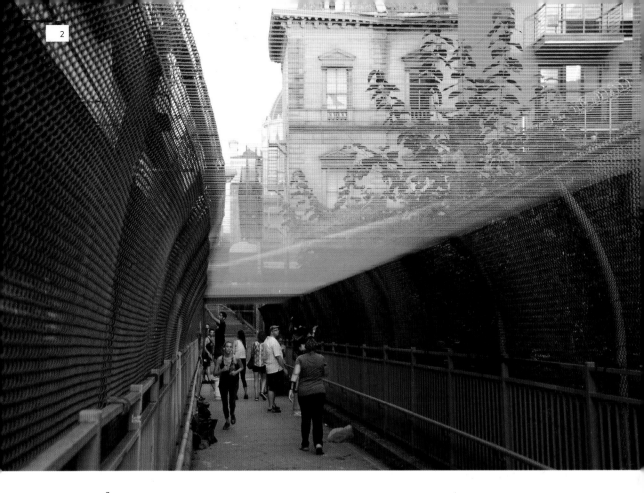

2

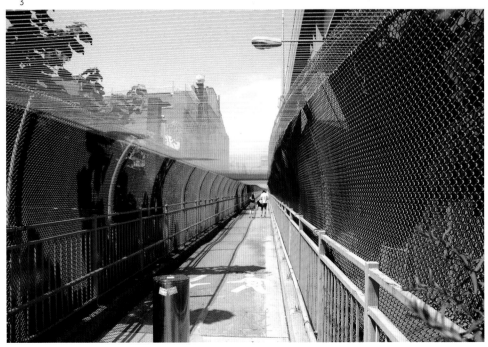

3

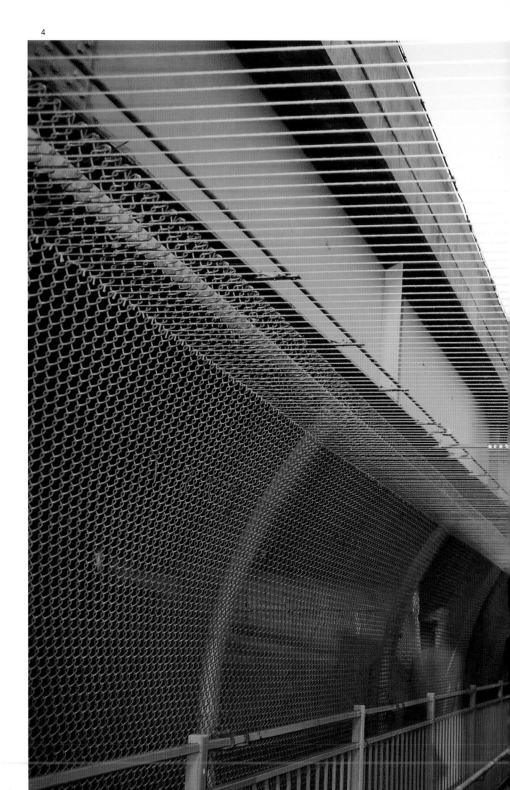

1

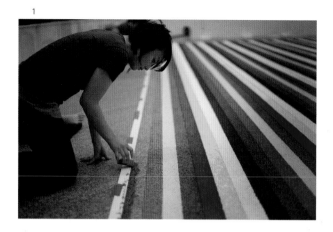

2

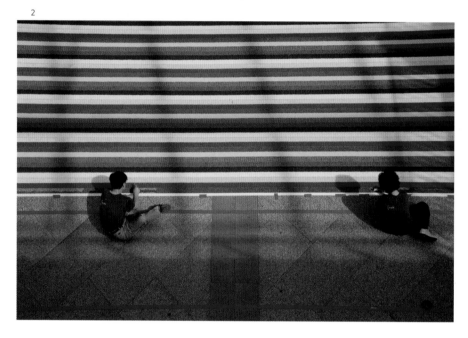

1–4
Spring Hiatus, **2011**
Atlanta, Georgia
Hand-shredded silk flowers

3

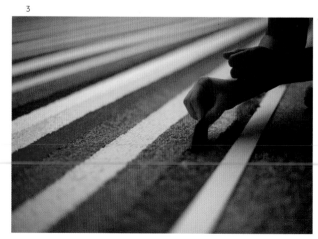

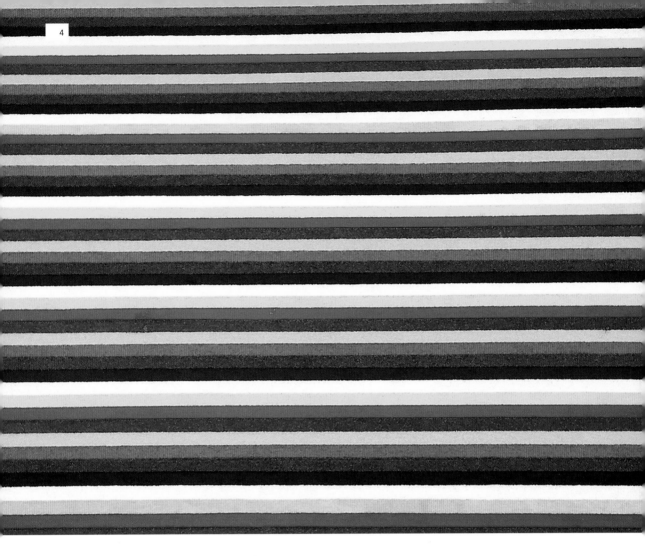

GYUN HUR

Hur's work explores elements of the ephemeral nature of beauty and life through installations of reappropriated silk flowers carefully arranged into immaculate, streamlined patterns. The project *Spring Hiatus* at Lenox Mall, Atlanta, Georgia, is her continual series of intricate rainbow installations, in which deconstructed silk flowers inspire recollections of her past and ties to Korea and her family. This public installation was commissioned by Flux Projects (fluxprojects.org) whose vision is to produce temporary public art to galvanize the city's cultural curiosity. The project required four months of hand-shredding silk flowers and two weeks of installation.

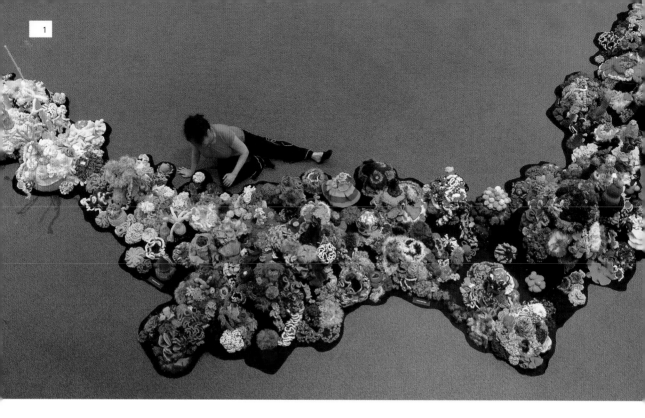

INSTITUTE FOR FIGURING

1
People's Reef, 2009
Scottsdale (Arizona) Civic Center
Crocheted yarn

2
Ladies Silurian Reef, 2009
Scottsdale (Arizona) Civic Center
Crocheted yarn

3
Detail of the *Latvian Satellite Reef* with coral by Dagnija Griezne, 2009
Crocheted yarn

Started in 2005 by sisters Margaret and Christine Wertheim of the Institute For Figuring, the *Crochet Coral Reef* project resides at the intersection of mathematics, marine biology, handicraft, and community art practice. Through a process of collective creativity, the project responds to the environmental crisis of global warming and the escalating problem of oceanic plastic trash by highlighting not only the damage humans do to the Earth's ecology, but also our power for positive action. The *Crochet Coral Reef* collection has been exhibited in art and science museums worldwide, including the Hayward Gallery (London) and the Smithsonian's National Museum of Natural History (Washington, D.C.). The project's Satellite Reef program has engaged thousands of people from all walks of life in more than a dozen countries. The *CCR* is one of the largest participatory "science + art" projects in the world.

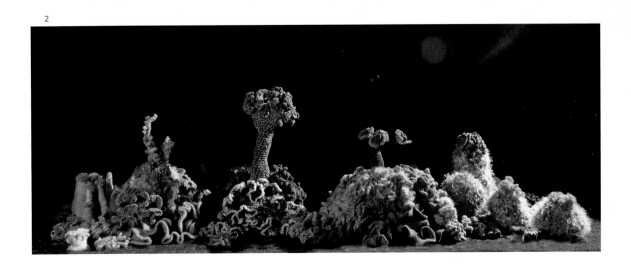

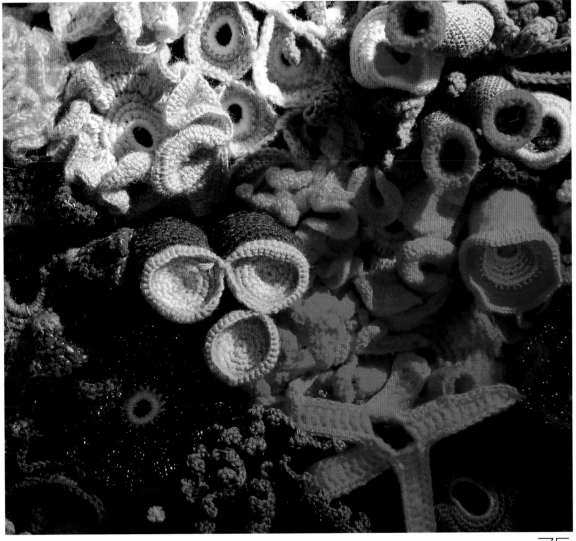

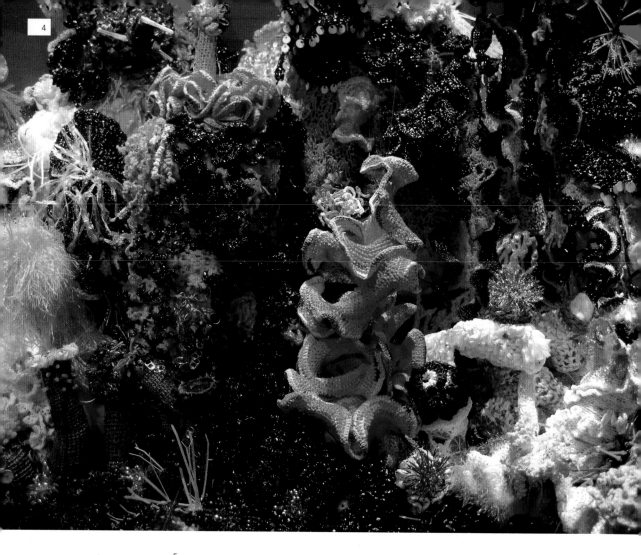

4
Detail of *Toxic Reef*, 2011
Smithsonian Institution, National
Museum of Natural History,
Washington, D.C.
Crocheted plastic

5
Giant Orange Coral, 2009
By Christine Wertheim
Crocheted yarn

6
Plastic-Bag Jellyfish, 2010
By Margaret Wertheim
Crocheted plastic

5

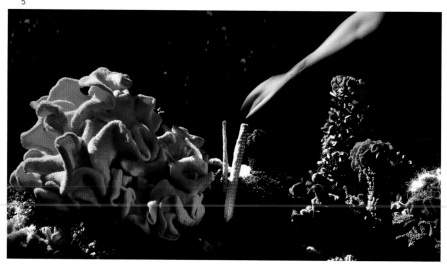

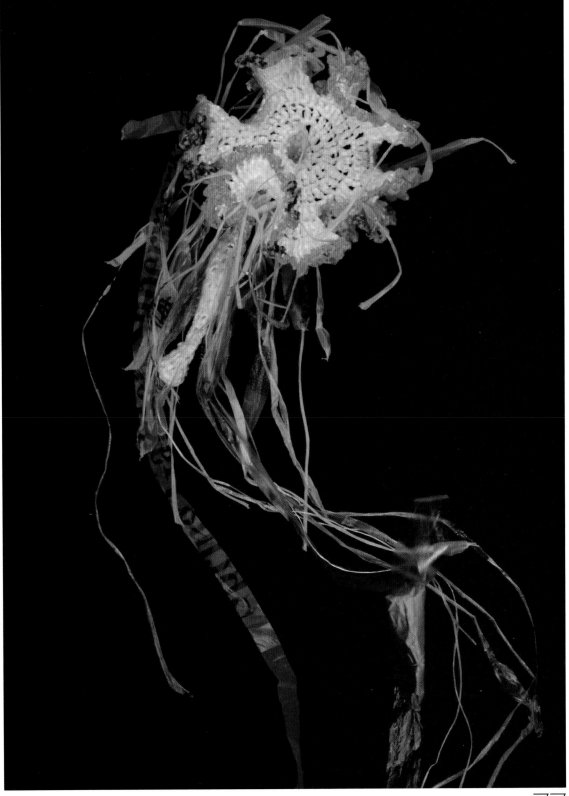

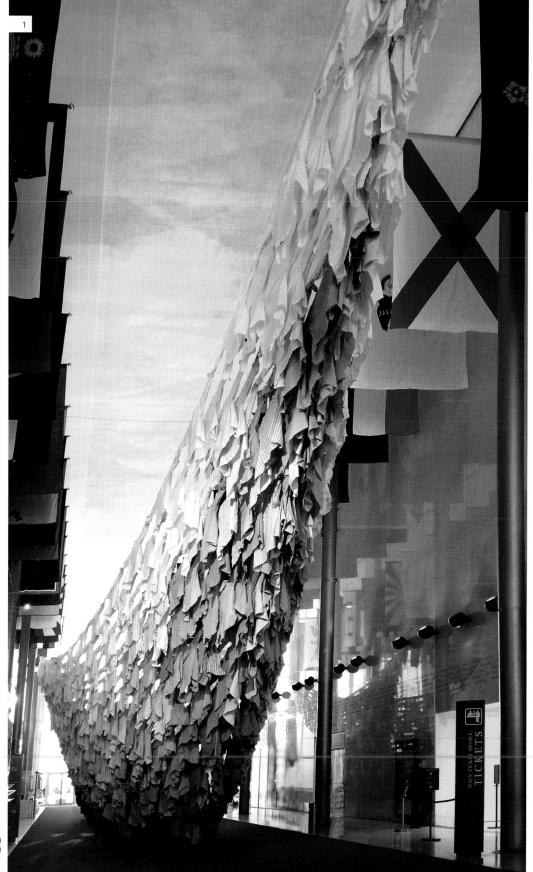

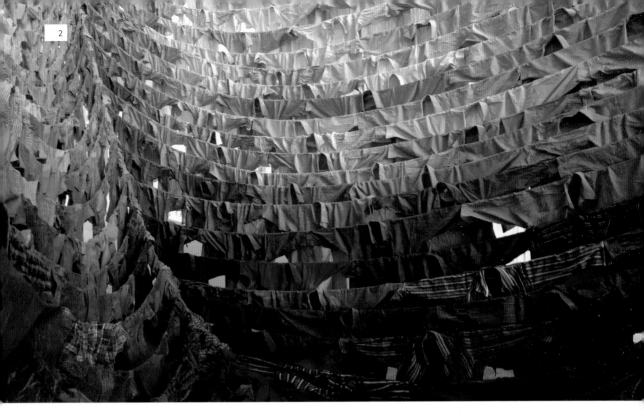

KAARINA KAIKKONEN

Commissioned by the Kennedy Center, *Are We Still Afloat,* a part of Nordic Cool 2013, took Finnish artist Kaarina Kaikkonen ten days to build. Using a thousand shirts belonging to people from the Washington, D.C., area, the artist fashioned a hanging 180-foot boat inside the Hall of States. The piece reflects Nordic culture in a number of ways, from the use of recycled materials and the historical significance of Viking ships to the water theme. ("We have many lakes in Finland; everybody goes by boat," the artist says.) There's something both sweet and haunting about the massive work, given that each article of clothing once belonged to someone. "There has been a warm loving heart inside each shirt," says the artist.

ERIK KESSELS

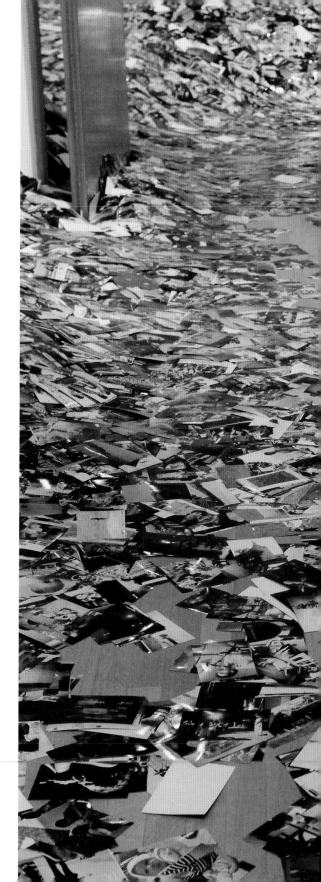

We're exposed to an overload of images. This glut is in large part the result of image-sharing and networking sites, and picture-based search engines. Their content mingles public and private, the very personal being openly and unself-consciously displayed. The art of photography, once the preserve of specialists, is now open to everyone. I wanted to explore this overwhelming flood of pictures and give the gallery visitor a physical means of grasping its vastness. By printing all the images uploaded in a twenty-four-hour period, I visualized the feeling of drowning in representations of other peoples' experiences. Where the installation is at first impressively monumental, it becomes intimate when people see the individuality of so many image makers, each with his or her own unique take on the world.

24HRS in Photos, 2011–2012
FOAM Amsterdam, Dec. 2011–Jan. 2012
350,000 photographs

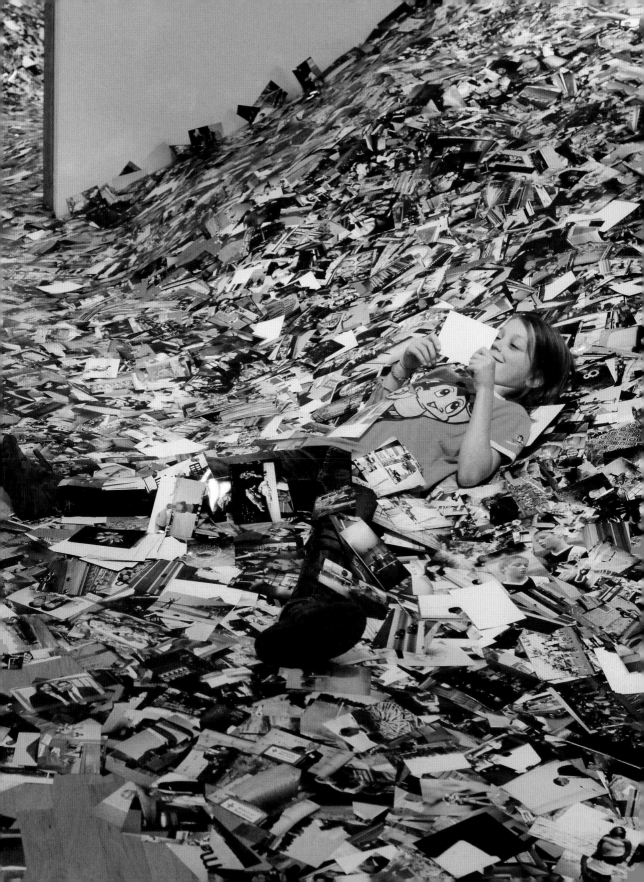

TETSUO KONDO ARCHITECTS

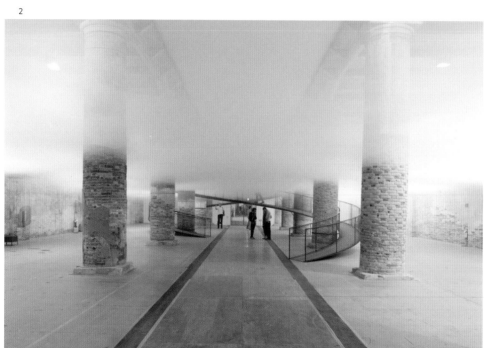

1–4
Cloudscapes, **2010**
Venice Architecture Biennale
Steel

Clouds frame outdoor space and filter sunlight. They are the visible part of the terrestrial water cycle, carrying water—the source of life—from the oceans to the land. Clouds find balance within stable equilibria and naturally sustain themselves, embodying and releasing solar energy. The ability to touch, feel, and walk through the clouds is a notion drawn from many of our fantasies. Gazing out of airplane windows, high above the earth, we often daydream of what it might be like to live in this ethereal world of fluffy vapor. Transsolar & Tetsuo Kondo Architects create *Cloudscapes*—with which visitors can experience a real cloud from below, within, and above—floating in the center of the Arsenale. The cloud is always changing and as such, the path taken through it becomes dynamic.

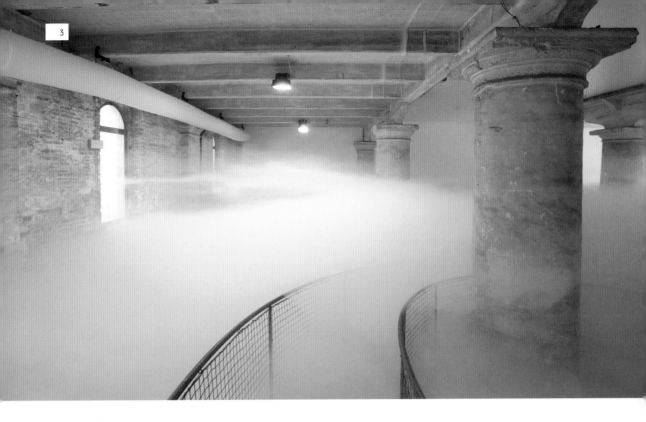

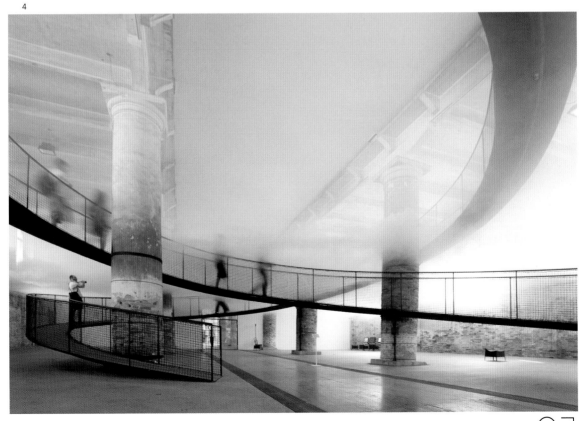

TOMOKO KONOIKE

1

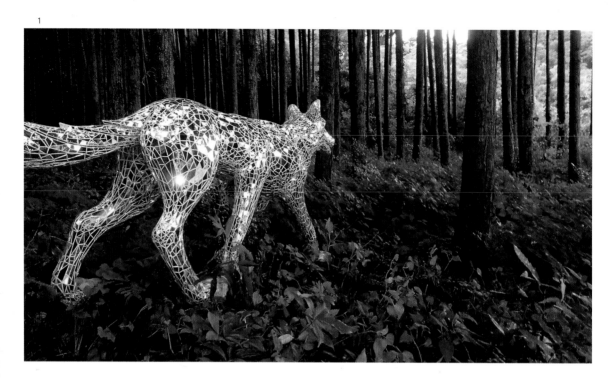

I consider my body not as an object, but first and foremost as a "place" for internal experience. I think of my artwork, then, as a sort of tool for shifting myself from this inner world of my body to another world. Therefore, instead of simply exhibiting my work inside the four walls of galleries, I also exhibit in various outdoor places as well. I value the connection between the place and the viewer who uses these tools (that is to say, who views my art). In fact, the appreciation of art is for me, more than anything, that singularly unique event or chance happening that occurs when the artwork and the viewer are brought together.

1
Mirrored Wolf, 2011
**Donning Animal Skins and
Braided Grass exhibition**
Mixed media (mirror, wood,
Styrofoam, and aluminum)
318 cm × 55 cm × 117 cm

2
Mirrored Wolf, 2006
**The Planet Is Covered by
Silvery Sleep exhibition**
Mixed media (mirror, wood,
Styrofoam, and aluminum)
318 cm × 55 cm × 117 cm

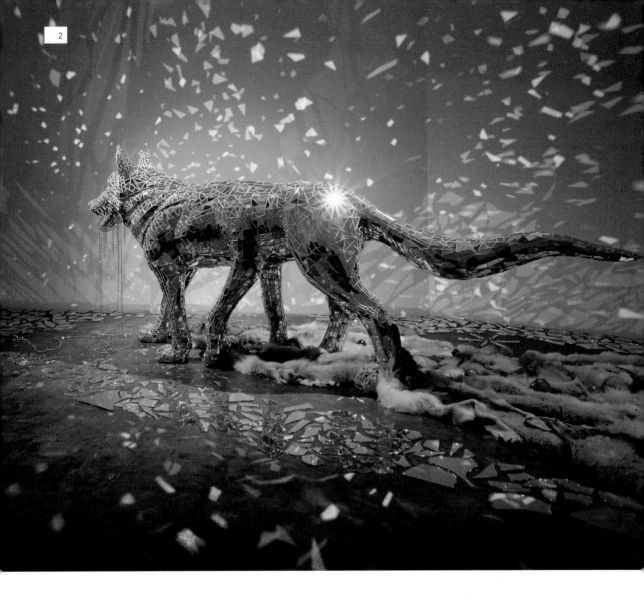

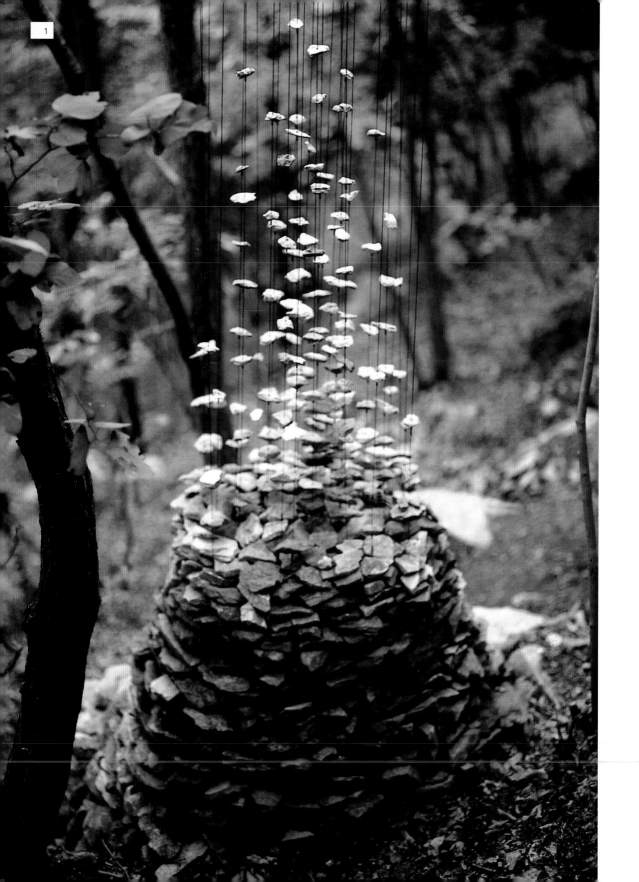

CORNELIA KONRADS

1–2
Pile of Wishes, 2004
In front of a cave, Geumgang Nature
Art Biennale, Gongju, Korea
Stones, steel rope, wire

"Pile of Wishes" refers to an ancient tradition I noticed while in Korea which also exists in other parts of the world: piling stones at special places. Each passerby adds a stone to the pile, each stone signifies a wish or a prayer. These piles congregate at points of concentrated energy such as temples, crossroads, and fountains. I'm fascinated by the intersection of a thought—an airy, transient, unseizable thing—with the oldest and most solid piece of our existence, a stone. While walking in the forest in Korea, I left the trail and came to a small plateau in front of a natural cave. It almost seemed to ask me to be recognized as a special place, so I created a *Pile of Wishes* there.

2

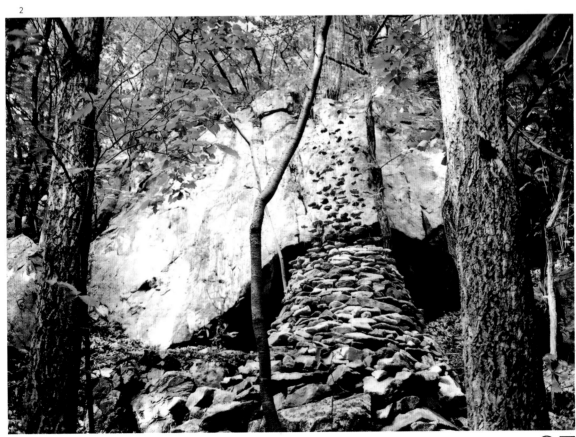

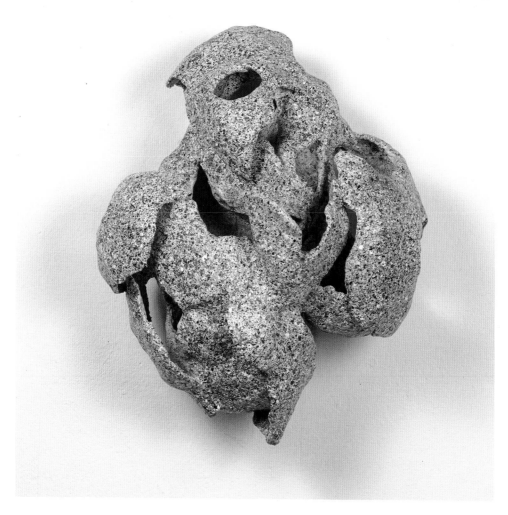

JORIS KUIPERS

1
Völlig Losgelöst (Loosened Completely)
(preludium), 2012
Plaster, resin, acrylic paint
38 cm × 36 cm × 32 cm

2
Völlig Losgelöst (Loosened Completely), 2012
Acrylic paint on Styrofoam
Approx. 340 cm × 350 cm × 340 cm

At first glance, the installation *Völlig Losgelöst* may seem no more than a colorful array of shapes. Upon closer inspection, however, all parts combine into an anthropomorphic skull, fanning out and dissolving, with the spectator at its center. The title *Völlig Losgelöst* ("loosened completely") refers to Peter Schilling's pop song "Major Tom" (1983), which describes the sensation of being weightless and the desire to simply vanish into space. Within the context of this artwork, weightlessness and hovering have a more spiritual meaning. Dissolving a human head refers to hallucinating, as a desire to escape, and, in a deeper context, letting go of one's ego. With my work, I try to give the viewer an experience of beauty, confusion, or catharsis.

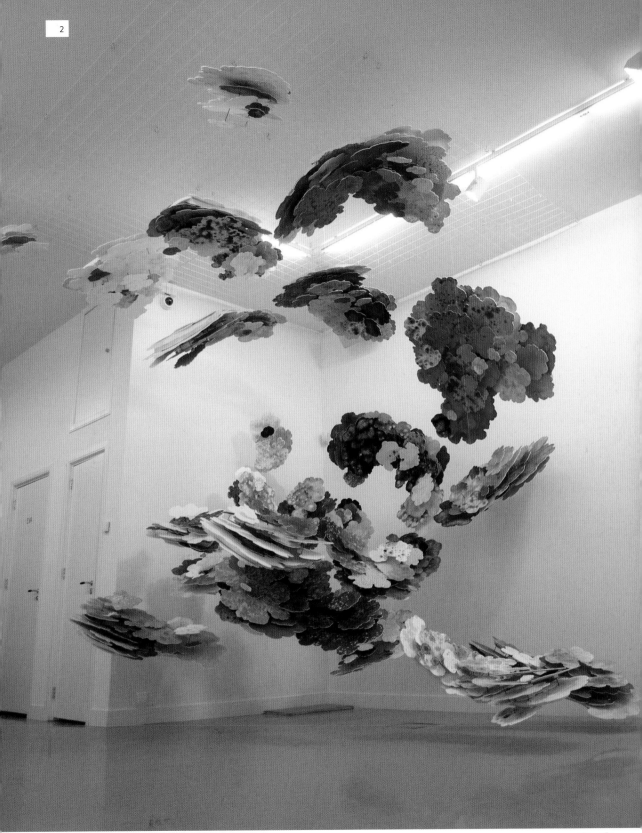

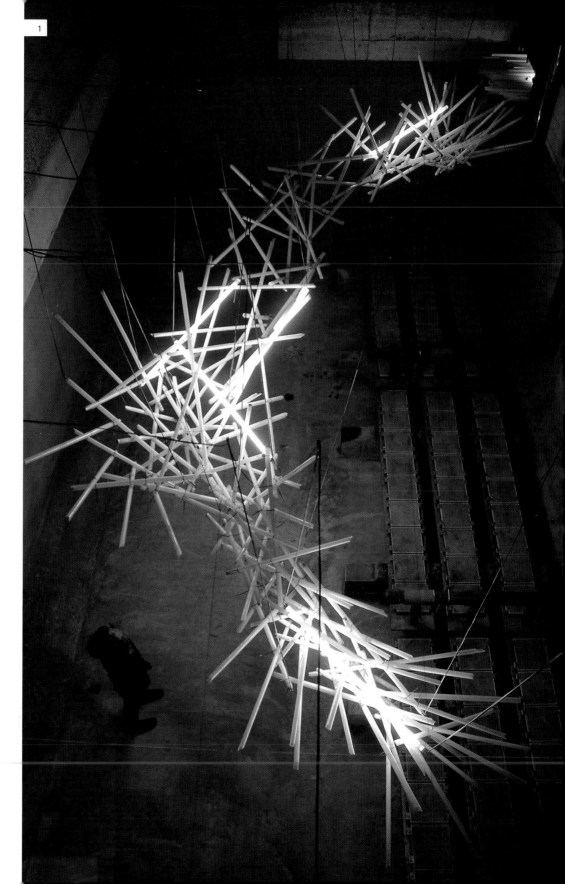

2

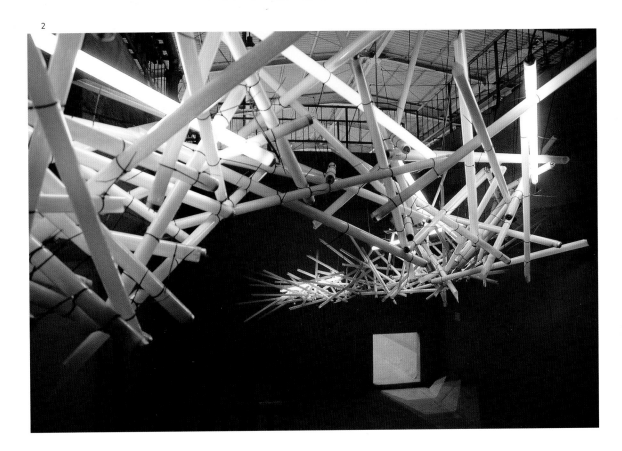

This work was installed in a water-purifier tank at a waste-water treatment plant site. By placing broken, blinking, and dying fluorescents in the space, the work represents ambiguous existence. The fluorescent light bulbs still exist there as bulbs even after they have lost their function as lighting equipment. This ambiguous and uncertain existence is also an element of the abandoned building. The unsteady blinking made by the dying and broken fluorescent lights, and the space lit by them, indicate the end and at the same time remind the viewers of the previous state of the fluorescents.

1–2
***Life-recollection*, 2006**
Fluorescent light, electric cable
4,600 mm × 4,800 mm × 9,500 mm

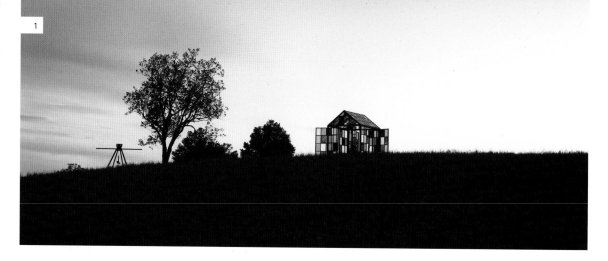

WILLIAM LAMSON

1–3
***Solarium*, April 2012**
Steel, glass, sugar, citrus trees
10' 10" × 8' 11" × 10' 3 ⅜"

Solarium is a colorized glass house consisting of 162 panels made of sugar cooked to different temperatures and then sealed between two panes of window glass. The space functions as both an experimental greenhouse, growing three species of miniature citrus trees, and a meditative environment. In warm months, a 5-by-8-foot panel on each side of the house opens up to allow viewers to enter and exit the house from all directions. In addition to creating a pavilion-like space, this design references the architecture of a plant leaf, where the stomata opens and closes to help regulate the plant's temperature. Like Thoreau's one-room cabin, the small structure in the open landscape references a tradition of isolated outposts designed for reflection.

2

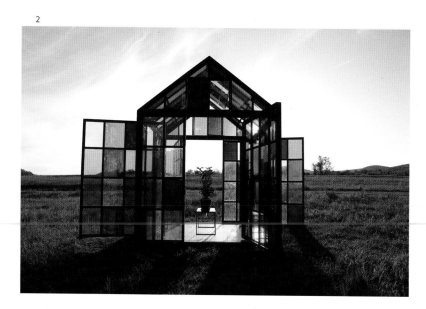

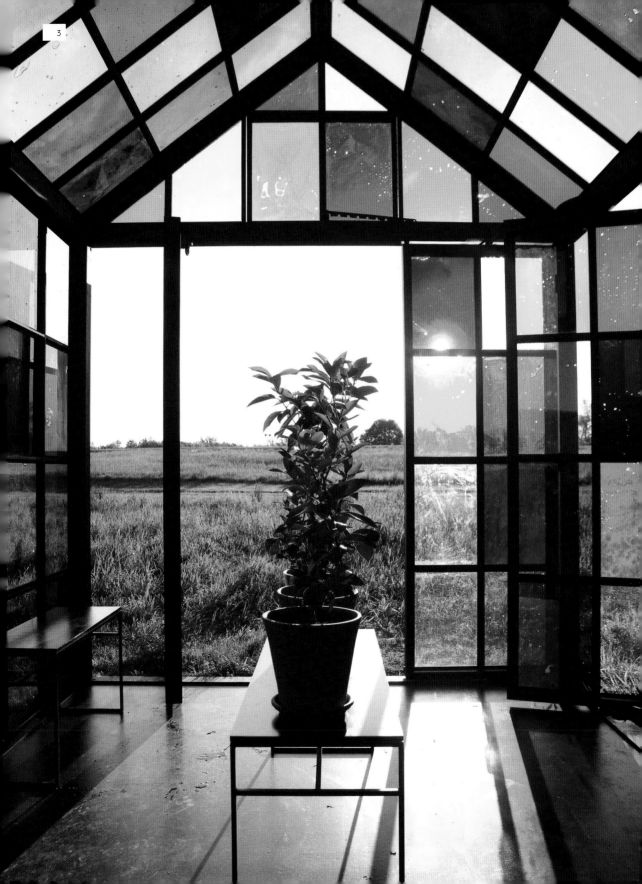

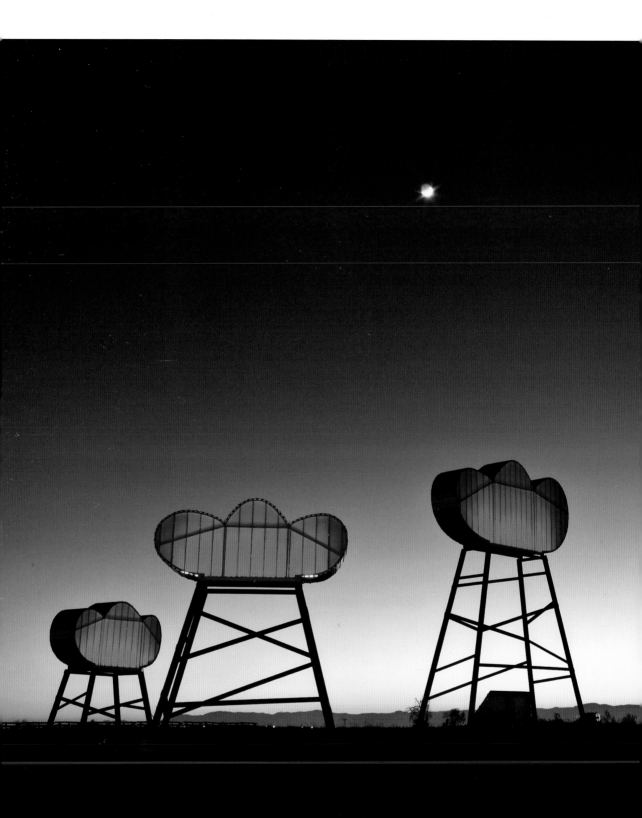

CHRISTOPHER M. LAVERY

Cloudscape was designed for the Denver International Airport. The large-scale nature of the project and the site posed many logistical challenges. The structure needed to be able to withstand tornado forces in the event of a storm. The site also had no convenient electrical supply, so we installed a small solar array, resulting in a project with a fully functioning electrical system; it was off the grid and didn't tax the environment or the public infrastructure. The materials used in *Cloudscape* were mostly recyclable or sourced from the recycling industry. Keeping the key elements of this project local—the design, engineering, and fabrication—kept costs down. The piece recalls the great plains of Colorado, echoing old farm windmills, drilling rigs, and water storage towers.

Cloudscape, 2008–2010
Denver International Airport
Steel, Polygal, LED lighting, solar panels

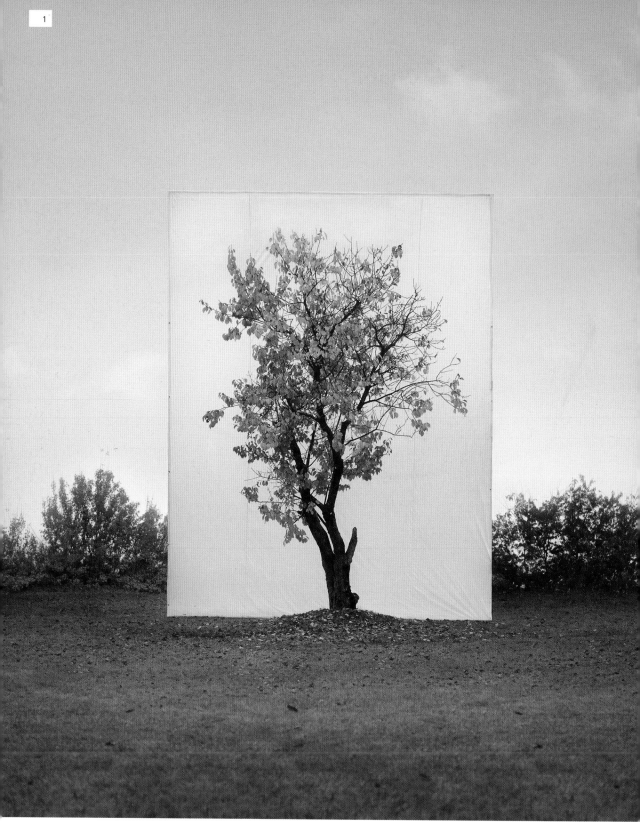

MYOUNG HO LEE

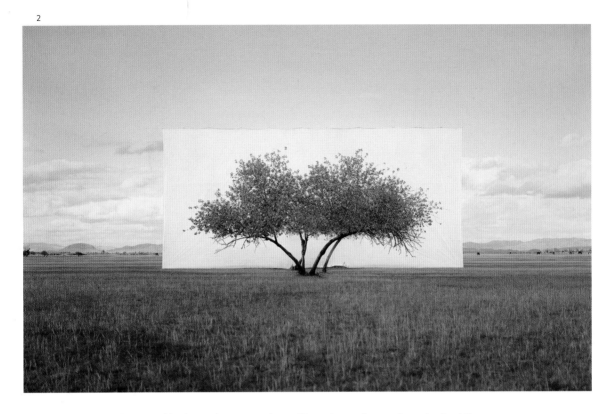

Myoung Ho Lee photographs solitary trees framed against white canvas backdrops in the middle of natural landscapes. To install the large canvases, which span approximately 60 by 45 feet, the artist enlists a production crew and heavy cranes. Minor components of the canvas support system, such as ropes or bars, are later removed from the photograph through minimal digital retouching, creating the illusion that the backdrop is floating behind the tree. Centered in the graphic compositions, the canvas defines the form of the tree and separates it from its environment. By creating a partial, temporary outdoor studio for each photograph, the artist's "portraits" of trees play with ideas of scale and perception while referencing traditional painting.

1
Tree #8, 2007, from the
series ***Tree***
Archival Inkjet Print
© Myoung Ho Lee, Courtesy
Yossi Milo Gallery, N.Y.

2
Tree . . . #2, 2011, from the
series ***Tree Abroad***
Archival Inkjet Print
© Myoung Ho Lee, Courtesy
Yossi Milo Gallery, N.Y.

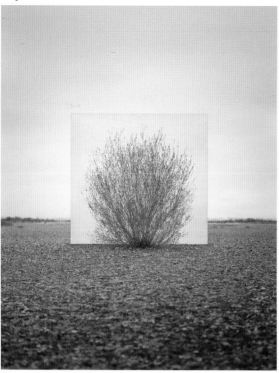

3
***Tree . . . #5*, 2014, from the
series *Tree Abroad***
Archival Inkjet Print
© Myoung Ho Lee, Courtesy
Yossi Milo Gallery, N.Y.

4
***Tree #12*, 2008, from the
series *Tree***
Archival Inkjet Print
© Myoung Ho Lee, Courtesy
Yossi Milo Gallery, N.Y.

5
***Tree #11*, 2005, from the
series *Tree***
Archival Inkjet Print
© Myoung Ho Lee, Courtesy
Yossi Milo Gallery, N.Y.

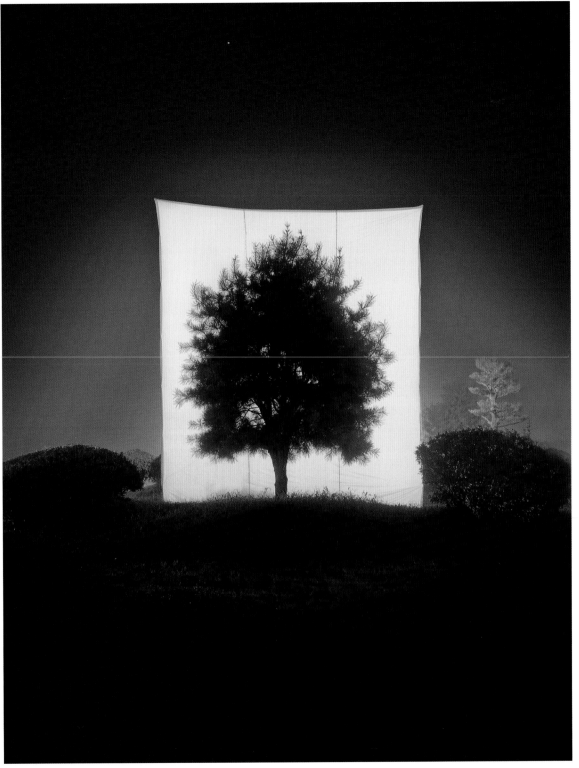

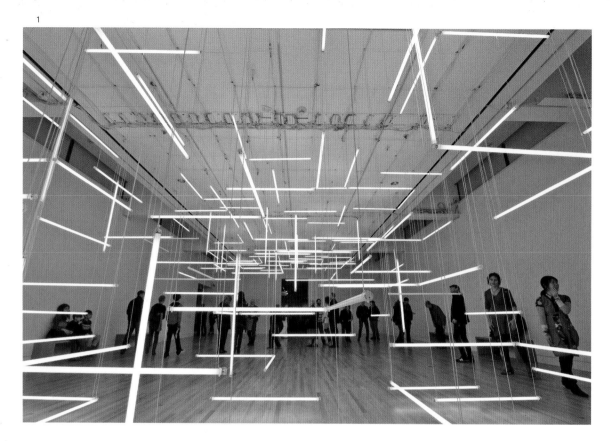

LILIENTHAL|ZAMORA

1–3
***THROUGH HOLLOW LANDS*, 2012**
Light installation

THROUGH HOLLOW LANDS is a sculptural light installation comprising 200 suspended fluorescent tubes. These lines of light create an articulated labyrinth describing an ascending volume overhead. Shapes grow and lapse as the light moves through the floating architecture, forming squares, rectangles, rooms, and constellations. The installation describes positive and negative space, filling the container and leaving a void, simultaneously acting as screen and open door for the line of sight. As viewers move through the space, they are immersed in the experience of the sculpture's interior, underside, and outskirts.

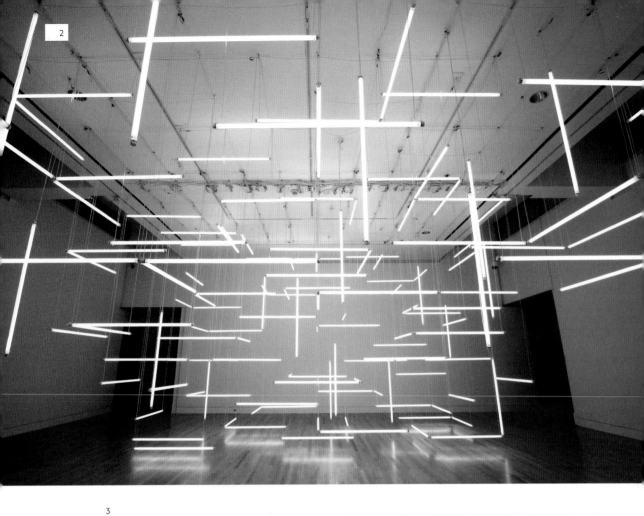

2

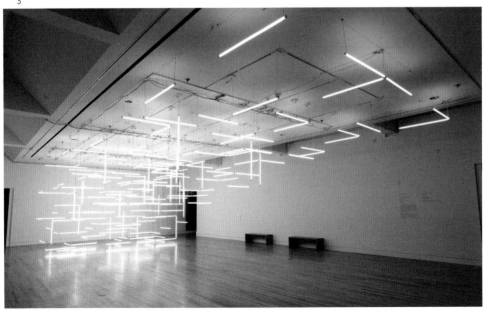

3

RAFAEL LOZANO-HEMMER

This installation was designed to transform the Park Avenue Tunnel in New York City. Three hundred theatrical spotlights that produce glimmering arches of light played along the tunnel's walls and ceiling. Participants controlled the intensity of each light by speaking into an intercom at the tunnel's center, which recorded their voices and looped them back. The individual voices could be heard on 150 loudspeakers as pedestrians walked through the tunnel, one speaker for each light arch, synchronized with it. At any given time, the tunnel rang with the voices of the past seventy-five participants. As new participants spoke into the intercom, older recordings moved down the light arches until they left the tunnel. The content of the piece was changing constantly.

2

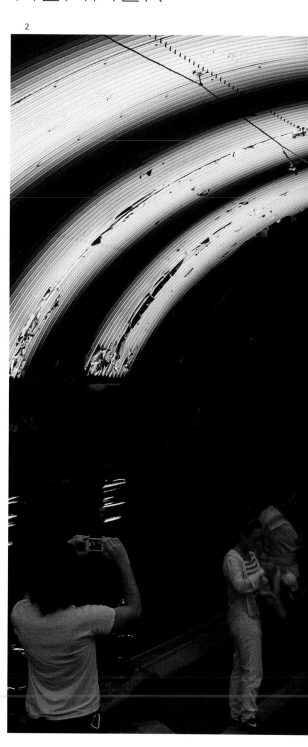

1

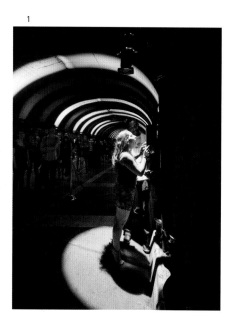

1–2
***Voice Tunnel, Relational Architecture 21*, 2013**
New York City, N.Y.
Custom-software, 300 × 750W source four spotlights,
ETC dimmer racks, speakers, computers, 22 miles of
Socapex power cable, 2.5 miles of fiber optic cable,
2 miles of XLR cable, 4 generators each supplying 500
amps, microphone, custom hardware
Tunnel is 427 m (1,400') long

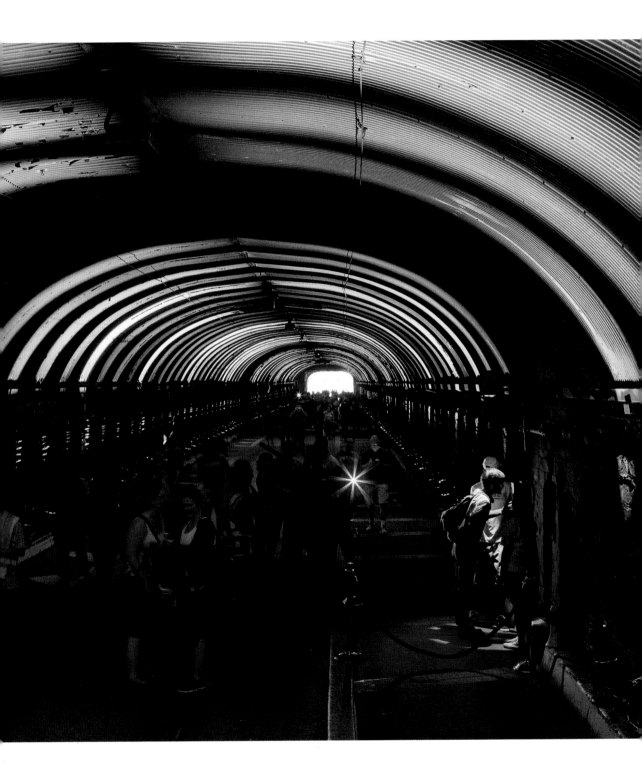

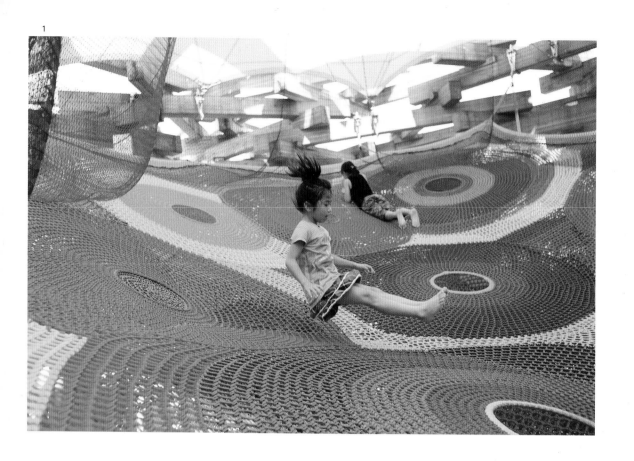

1

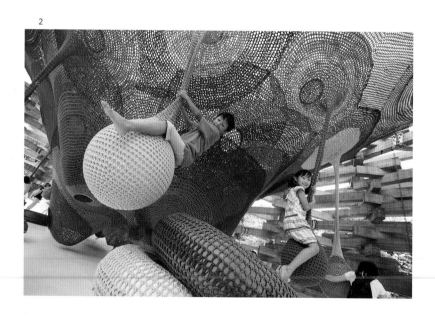

2

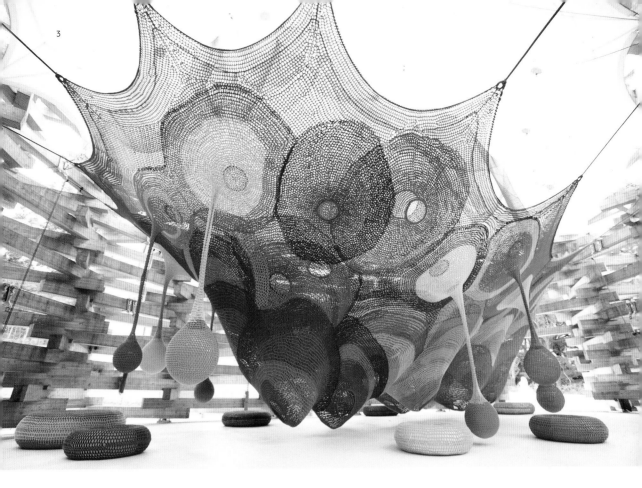

TOSHIHIKO HORIUCHI MACADAM

1–3
***Knitted WonderSpace II*, 2009**
Hand-crocheted braided nylon 6-6

Knitted WonderSpace II was commissioned by the Hakone Open Air Museum to replace one of my earliest pieces, from 1981. The work reflects my husband, Charles, and my desire to touch people in their daily lives and to engage them with the work through all of their senses. The energy of children especially brings it to life. As a functional textile, over the years it will become worn out and discarded, but it will remain as a joyful memory for the children who have played on it and interacted with others through it.

Yui and Takaharu Tezuka's remarkable structure, like a giant bird's nest, comprises 580 individually shaped beams. Like traditional Japanese architecture, it is held together with wooden dowels and wedges. It was also engineered by our longtime collaborator, Norihide Imagawa.

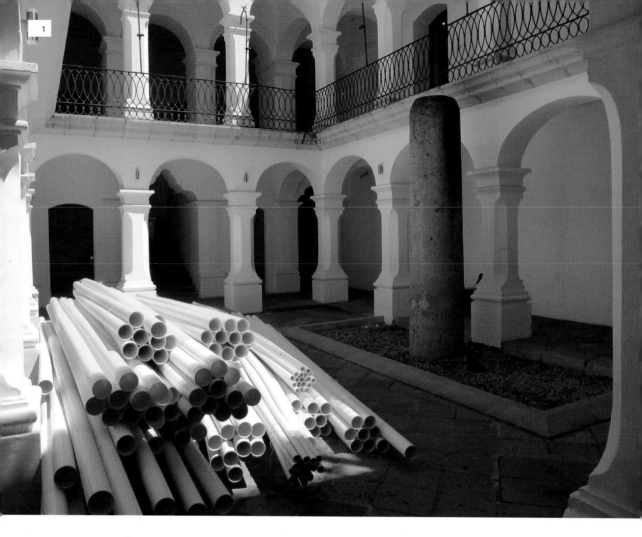

RUSSELL MALTZ

1–2
***Painted/Stacked Oaxaca*, 2012**
Museo de los Pintores
Oaxaqueños, Oaxaca, Mexico
DayGlo Enamel SCR # 17 and
Sunlight on PVC pipes
Dimensions variable

For the Museo de las Pintores Oaxaqueños, Maltz used large PVC plumbing tubes of different dimensions. Although they appeared to be casually stacked in the museum's courtyard, Maltz had placed them with great care to create a harmonious composition for the space. Maltz delineated an area of the tube's surfaces and painted them a fluorescent yellow color. The direct sunlight entered the courtyard during certain hours of the day to saturate the space with a greenish yellow reflection, something unexpected in a seventeenth-century colonial building. The installation has since been disassembled and its yellow light has disappeared, but the work of Maltz will remain in Oaxaca, hidden and sometimes visible in the city's architecture and plumbing.

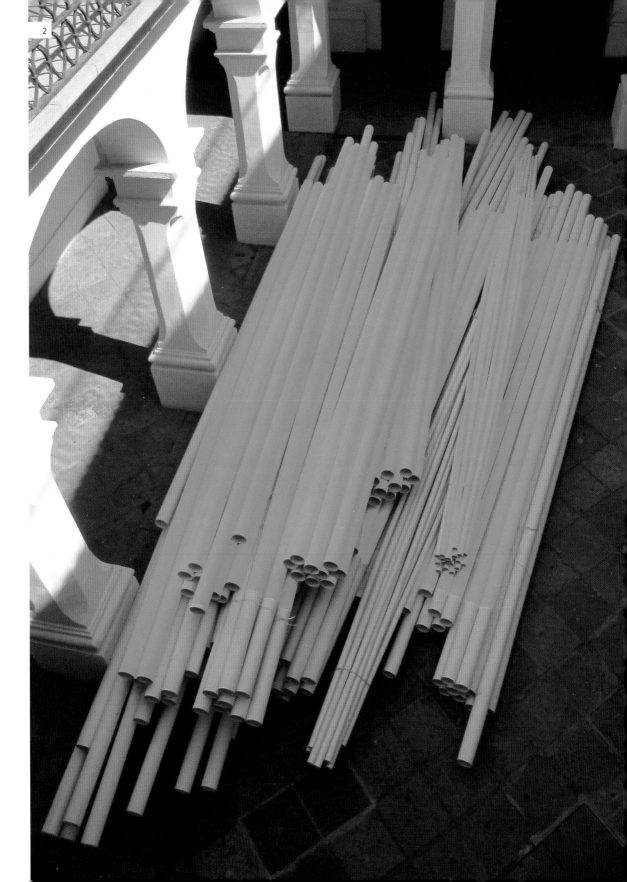

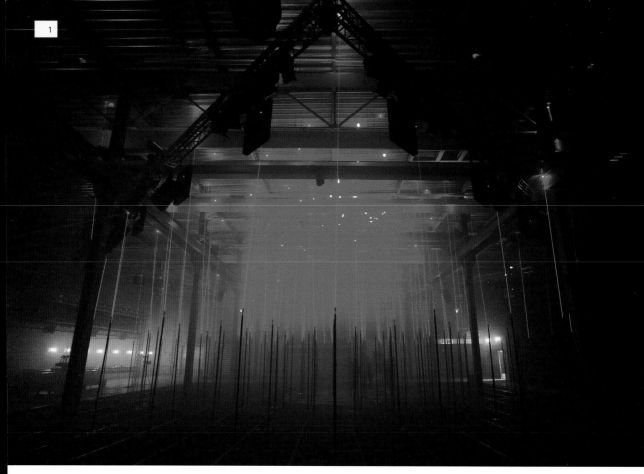

MARSHMALLOW LASER FEAST

1–3
***Forest*, 2013**
Steel rods and plates, laser diodes
21 m × 21 m × 6 m

Commissioned by and premiered at the STRP Biennale in Eindhoven, Netherlands, this giant interactive forest covers 450 square meters and comprises more than 150 musical "trees" made of rods and lasers. The audience can freely explore the space, physically tapping, shaking, plucking, and vibrating the trees to trigger sounds and lasers. Due to the natural springiness of the material, interacting with the trees causes them to swing and oscillate, creating vibrating patterns of light and sound. Each tree is tuned to a specific tone, creating harmonious sounds spatialized and played through a powerful surround sound setup. The installation is designed to bring out child-like feelings of curiosity and wonder in the audience as they learn how to interact and play within the space.

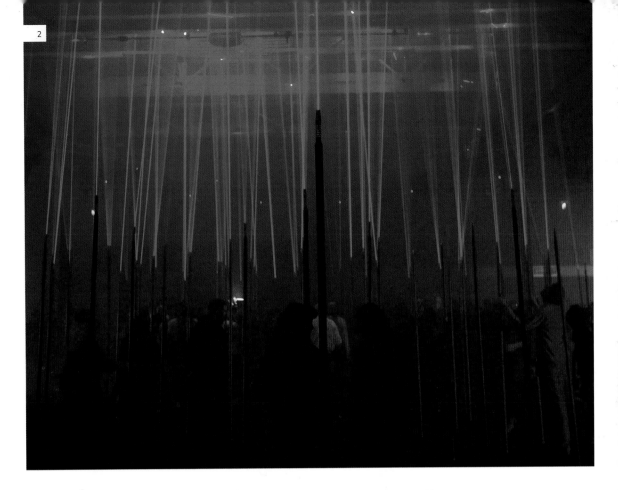

2

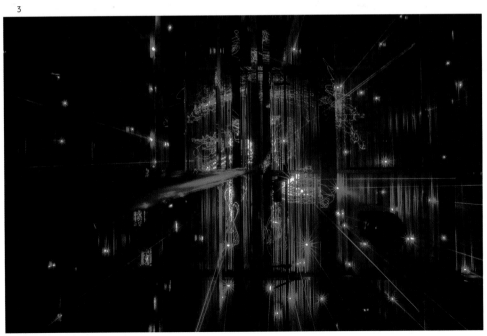

3

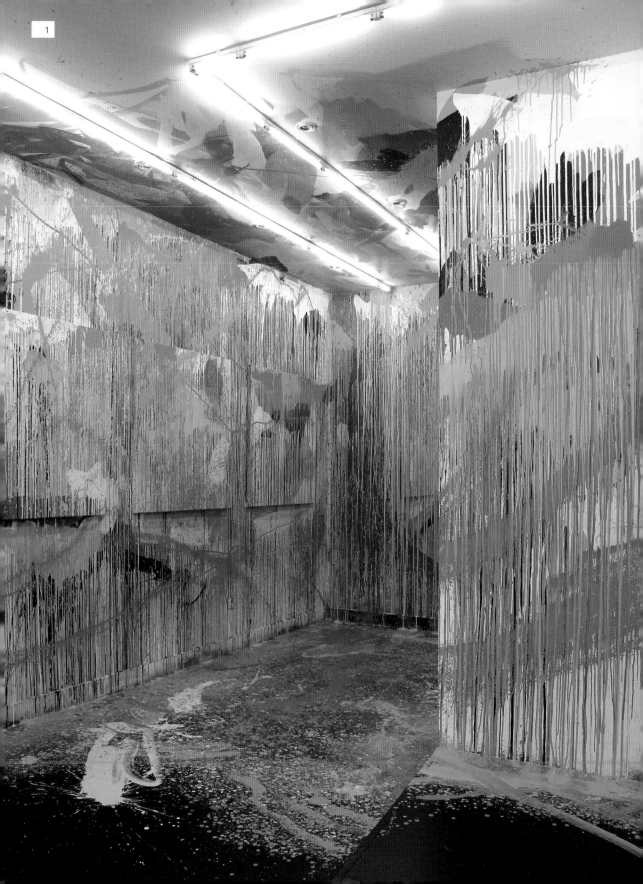

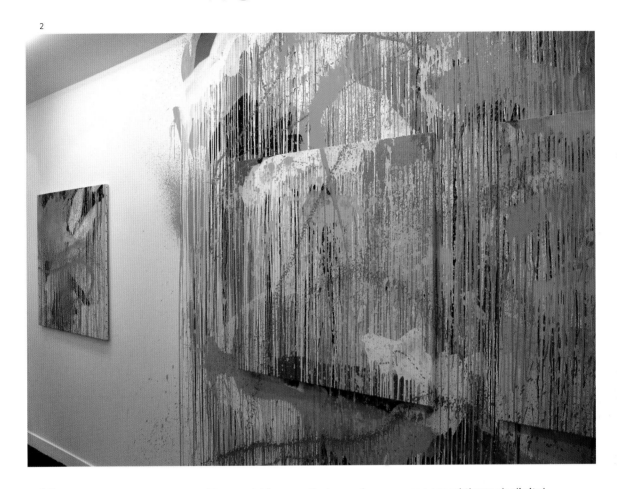

2

1–2
Afterglow, 2011
Lyon, France
Acrylic paint on canvas, walls,
floor, ceiling

The world is a small place when you can travel through digital means. *Afterglow* is the result of two creative forces from different sides of the globe connecting, a gallery owner in France collaborating with a vibrant abstract expressionist painter from Australia. What resulted when their ideas became a reality was this explosion of creative output within the confined space of a small gallery in Lyon, France. *Afterglow* sets a new standard in the presentation of how contemporary painting can be viewed in a gallery context. Rowena Martinich's bold gestural painting practice becomes an explosive dance of color, line, and energy that a canvas cannot hold alone. *Afterglow* is an immersive experience for the viewer, where one enters the artist's physical and emotional space and process.

MADEMOISELLE MAURICE

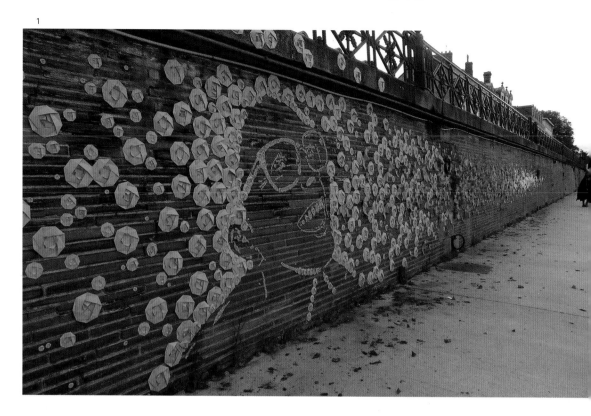

1

This installation, created for an urban art festival in Angers, is based on the story of one thousand paper cranes and Sadako's story, a little girl who lived during the tragedy of Hiroshima. In the month prior to the installation, workshops were organized with the artist and the people of the city, students, retired people, prisoners—anybody who wanted to participate. People learned to fold while discovering the purpose of the project. I wanted to provide color to the gray city, and through color, positive emotions. The installation provided what looked like a field of flowers on the stairs and on one wall of the cathedral. Each origami represents one person, with the result demonstrating the positive fruits of working together.

1–2
Spectrum, 2013
Angers, France
Folded paper

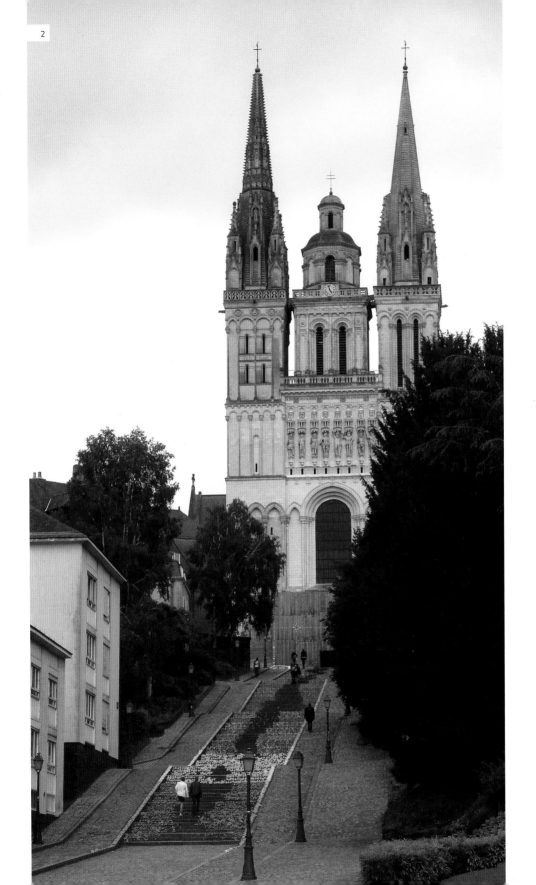

SHELLEY MILLER

1–3
***Stained*, 2011**
Hand-painted fondant sugar
tiles, piped icing sugar on wall
88" × 75"

I have been working with sugar as a medium for more than fifteen years, using it as a metaphor for "the feminine," domesticity, and aesthetic taste, as well as desire and excess in contemporary consumer culture. My focus in recent years has been on sugar itself: its historical links to slavery and colonization, and its global socioeconomic impact. The research and inspiration for this work is rooted in the historical context of Brazil. I subvert traditional *azulejo* tile murals by using sugar to replicate the appearance of ceramic tiles. The degenerative process of these temporal murals references the many dichotomies that circumnavigate the seeming innocuous substance of sugar: conquerors versus conquered, gain versus loss, the wealth of some and the ruin of others.

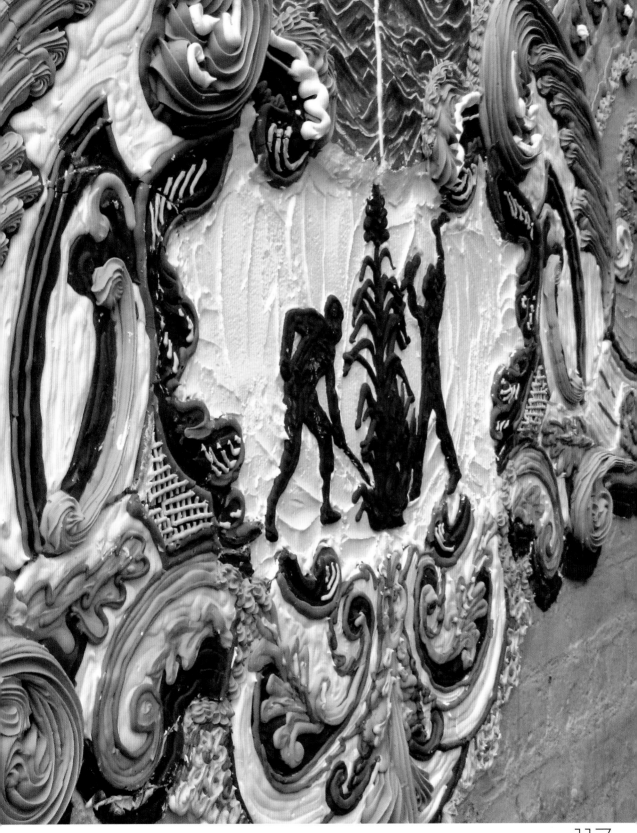

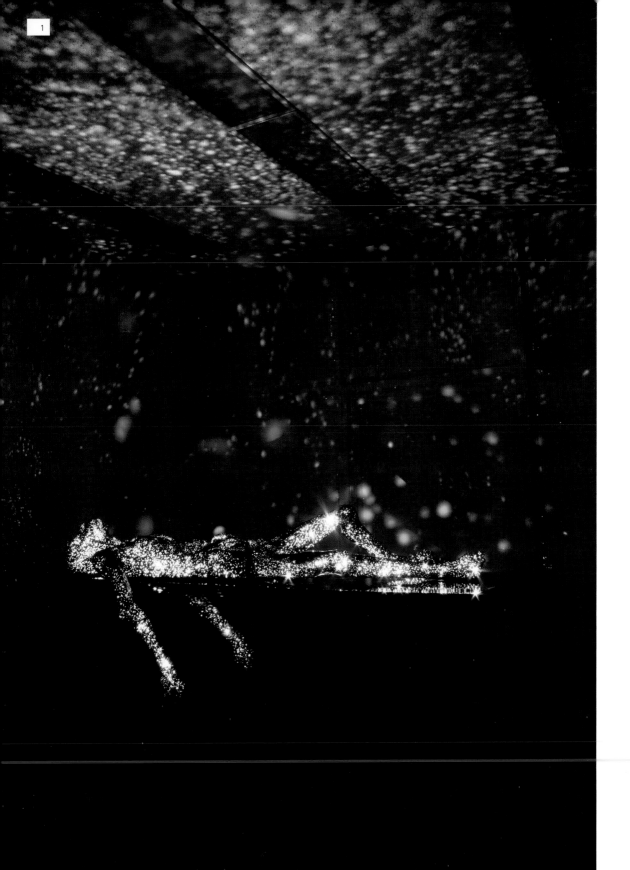

MIHOKO OGAKI

This human form, composed of fiber-reinforced plastic (FRP), is pierced with an indefinite number of pinholes. There is a light source embedded within the human form: When on, it glows like the galaxy. Humans are composed not only of matter, such as flesh and bone, but also of emotions—an astronomical number. The holes serve as a metaphor for the emotions (for example, fear or adoration) of which we are comprised. Regarded this way, humans and the universe seem synonymous; it is this concept that my whole series was based on.

1 & 4
Milky Way–Breath 02, 2010
Fiber-reinforced plastic (FRP),
LED with dimmer, wood
190.5 cm × 107 cm × 108 cm

2
Milky Way–Breath 01, 2009
Fiber-reinforced plastic (FRP),
LED with dimmer
48 cm × 54 cm × 34 cm

3
Milky Way, 2008
Fiber-reinforced plastic (FRP),
LED
76 cm × 90 cm × 85 cm

2

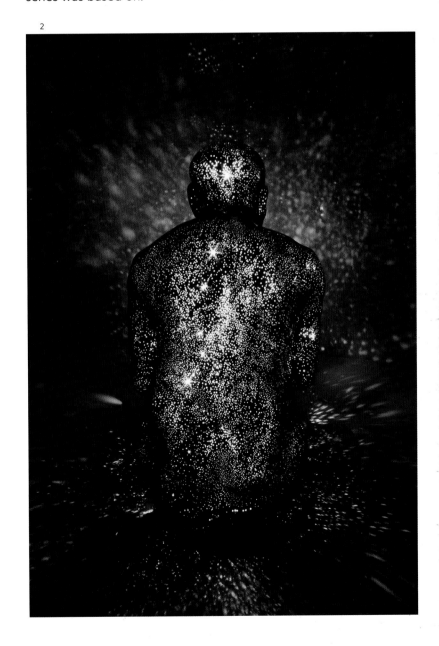

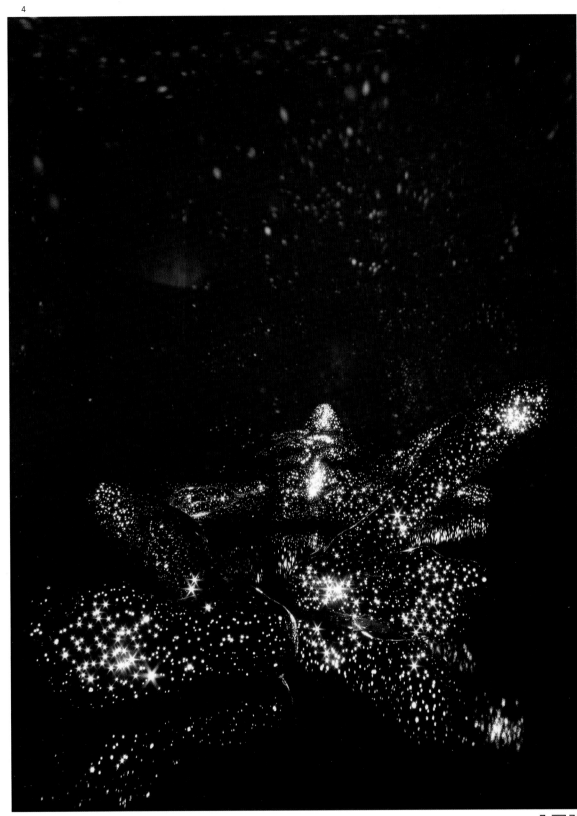

KIMIHIKO OKADA

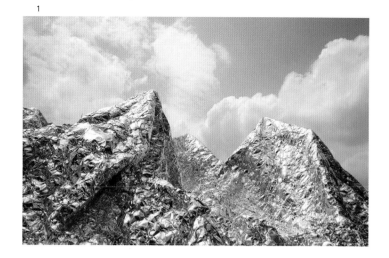

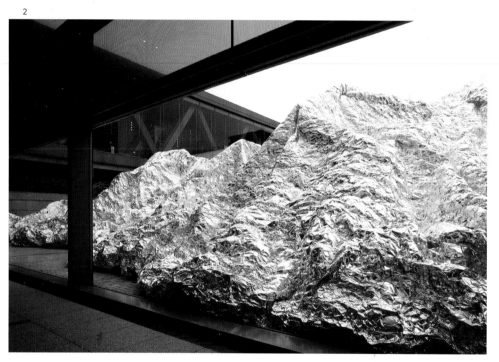

1–3
Aluminum Landscape, 2008
Museum of Contemporary Art, Tokyo
Aluminum sheet (0.08 mm), steel pipe
740 m², height 8 m

This object may seem as if it comes from nature in the way it reflects its surroundings—the changes in weather, the sun's rays, or the colors of the sky. Yet it is artificial, its complex geometrical balance achieved by one huge aluminum sheet. There are intrinsic conflicts within the material and process that create this outcome. Aluminum is hard but smooth. The exhibit is organically formed and yet consists of innumerable geometrical shapes.

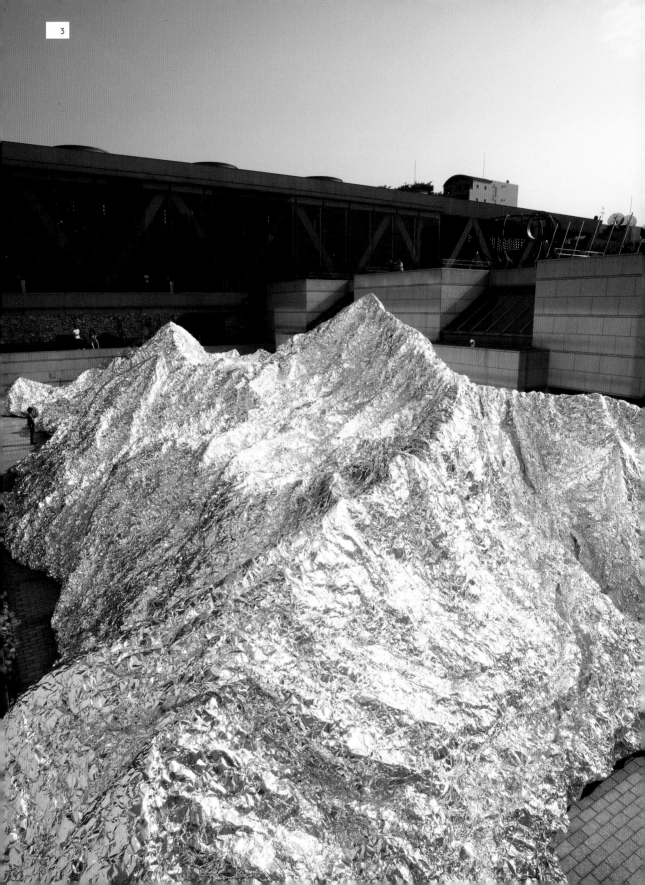

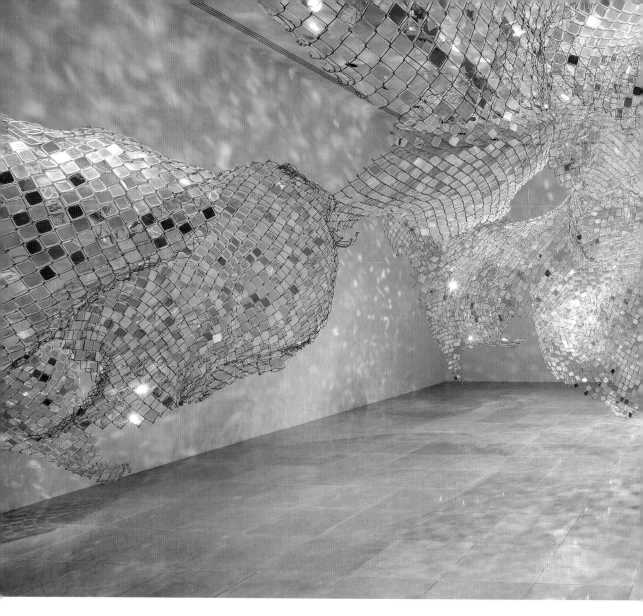

SOO SUNNY PARK

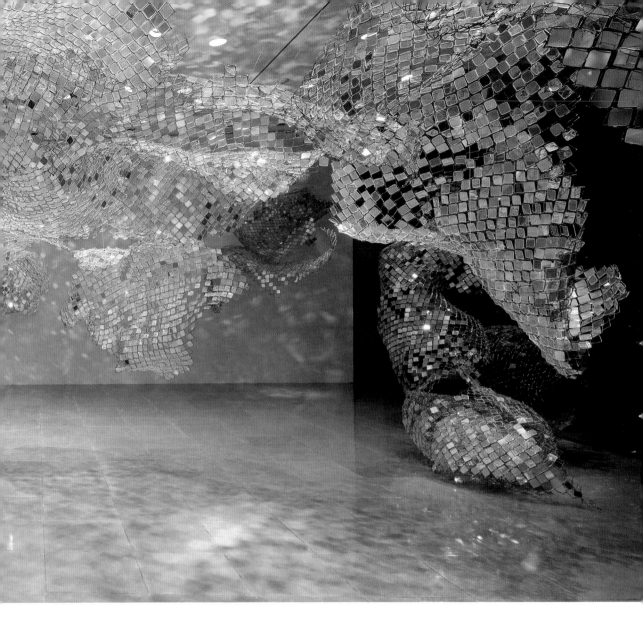

***Unwoven Light*, 2013**
Rice University Art Gallery, Houston, Texas
Brazed chain-link fence, plexiglass, natural
and artificial light
15.5' × 44' × 40'

The woven form of a chain-link fence, fitted with dichroic plexiglass diamonds, unweaves the light that illuminates it. Now we can see the light, in purple shadows and yellow-green reflections that both mirror the shape of the fence and restructure the space they inhabit. Fences and panes of glass are porous boundaries. They divide yours from mine, inside from outside, but both let light pass through. The boundary materials don't divide us or the spaces we occupy: They divide the light. It's important to me that this work does not hide the materiality of fence and glass in order to focus viewers on light; rather, it enfranchises light as a sculptural material. Light no longer merely reveals the sculpture's elements: It is one.

PAOLA PIVI

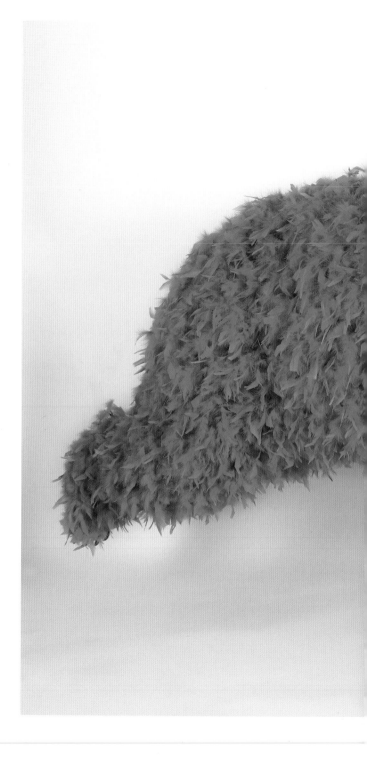

Pivi is careful not to state the meaning of her pieces. The task of constructing symbolic importance is one that viewers self-assign, and to do so many recount anecdotes and draw on personal associations, indicating the specificity implicit in Pivi's arrangements. These experiences cannot be adequately theorized in broad strokes. When external frameworks are applied, the most apt seem to be immediate, visceral, and sometimes somewhat mystical: a religious text, the chemistry of the brain, the prophetic words of a philosopher on the brink of insanity.

Excerpt from "Say it like you mean it" by Jens Hoffmann

"Who told you white men can jump?" **2013**
Urethane foam, plastic, feathers
32.25" × 96.5" × 52" (82 cm × 245 cm × 132 cm)

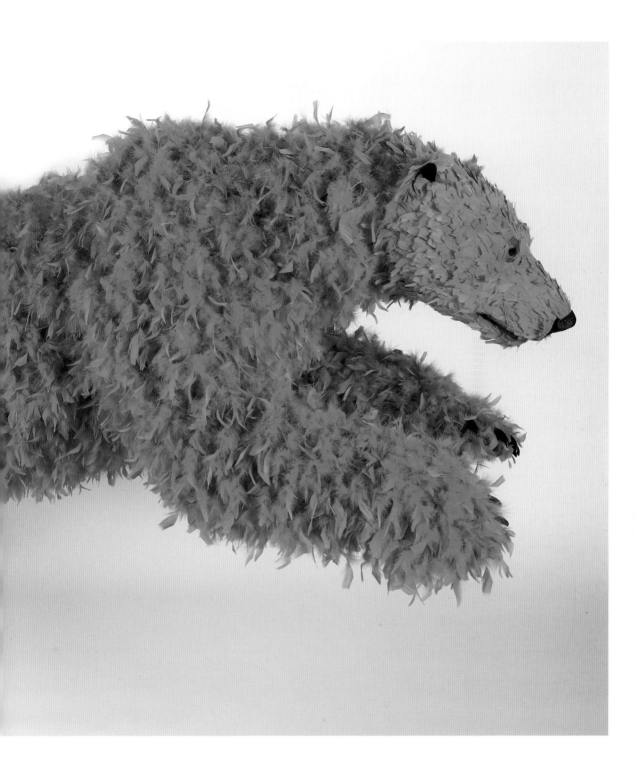

MALENE HARTMANN RASMUSSEN

1–2
***Fire Walk With Me*, 2010**
Ceramics

I try to create a place beyond reality, a deceitful echo of the real world, that bends the perception of what is real. I want my work to look like a very skilled child could have made it, clumsy and elaborate at the same time. Initially the viewer may, mistakenly, be drawn to my figures thinking them to be toys; however closer examination reveals their darker narrative. They invite you into an absurd and surreal world. The filmic references in this piece are strong. The title refers to the David Lynch TV series *Twin Peaks*, with its ongoing themes of "things are not what they seem" and "fire walk with me." It shows a frozen moment of dark passion and hidden lust.

1

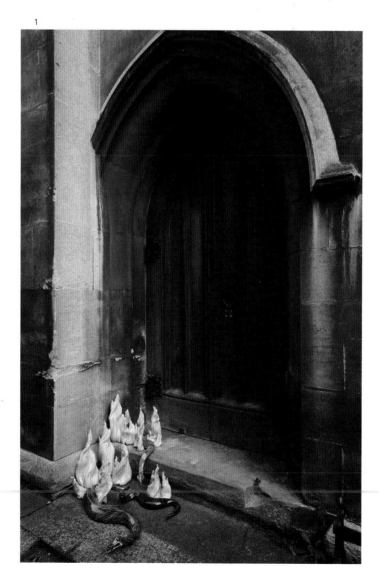

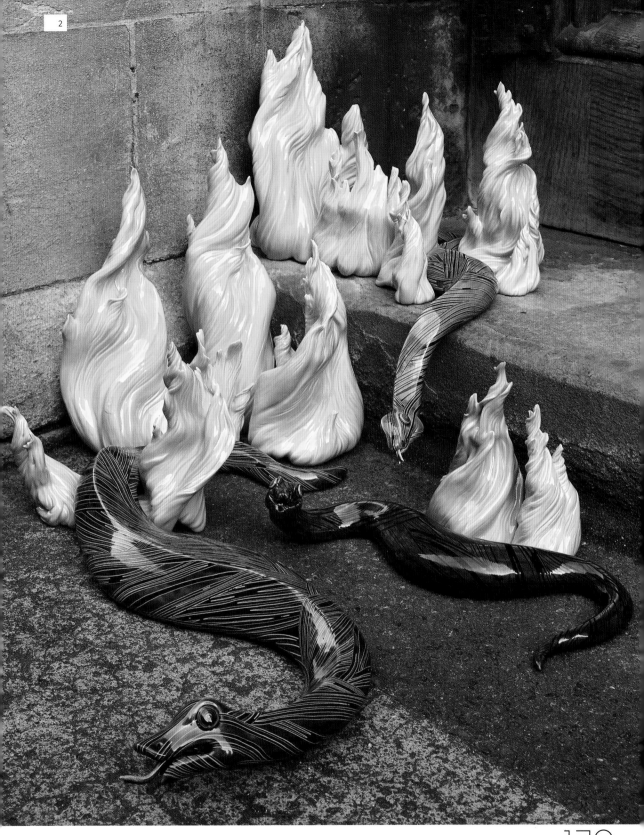

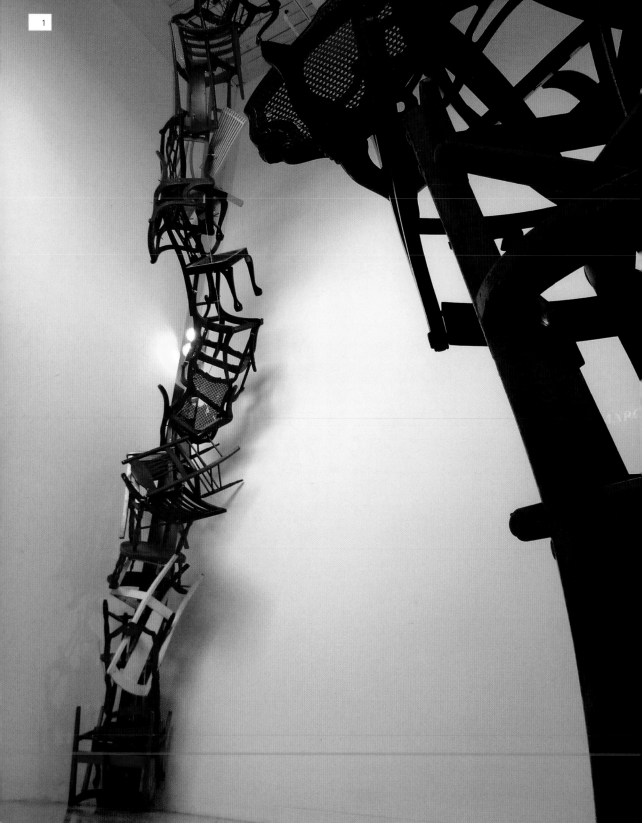

MARC ANDRE ROBINSON

1–2
***Oupop's Arch* from the solo
exhibition *Inheritance*, 2010**
Maryland Institute College of Art
Wood

Marc Andre Robinson's artistic practice revolves around a situated awareness of historical, cultural, and familial relations of belonging. Robinson is interested in historically loaded objects, icons, and images. Drawn toward the banal and often discarded furniture of daily life, his assemblages distill the hidden power relations embedded within these everyday things. Depriving commonplace objects of their historical innocence, Robinson exposes the historic struggles of race, class, and gender that silently shape their perception. These gestures of desublimation, in which we perceive the mechanisms through which the brutal debris of the past is swept into the present, disturb our sensory habits and encourage us to question the routine. Even if temporary, such awareness generates the potential for a critical reappraisal of our surroundings, and the entangled historical and biographical narratives that frame our apprehension.

2

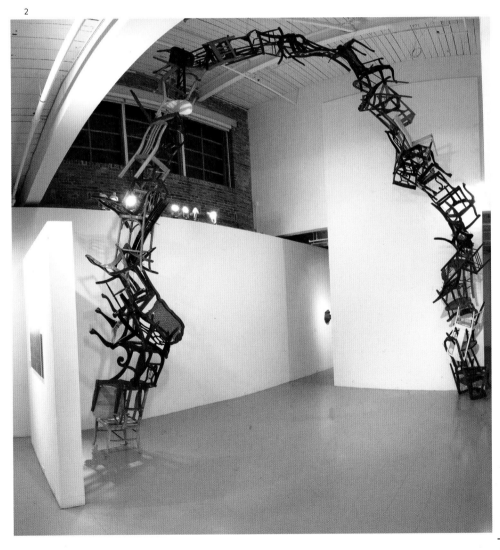

RUB KANDY

What makes the artwork? The hand? The mind? The machine? The time? The place? The spectators?

1

2

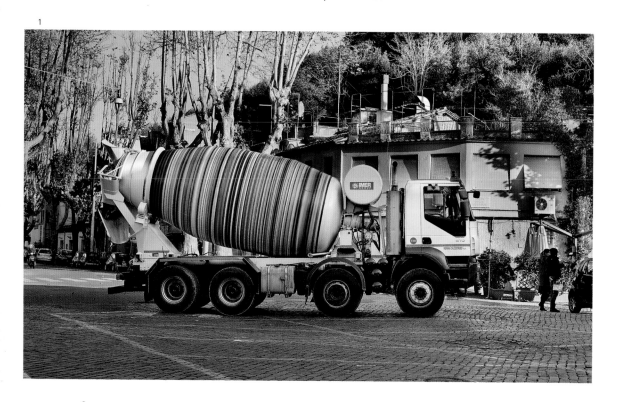

1–4
REVOLVER, 2011
Rome
Spray paint

ÁLVARO SÁNCHEZ-MONTAÑÉS

1–3
Indoor Desert, 2009
Kolmanskuppe, Namibia
Baryta inkjet print

By the end of World War I, diamond mines in Kolmanskuppe, a site in the Namib Desert, ceased to be exploited. For more than two decades, it had been one of the wealthiest settlements in Southern Africa. During that time of splendor, the German colonists who ran the site had built their peculiar residences there, evoking the architecture and décor of those in their homeland, Bavaria. After it was closed down and its inhabitants left, Kolmanskuppe became a ghost town engulfed by desert sands. With his series *Indoor Desert*, Álvaro Sánchez-Montañés enters these houses abandoned to the desert to unveil the serene enchantment that dwells in their chambers.

1

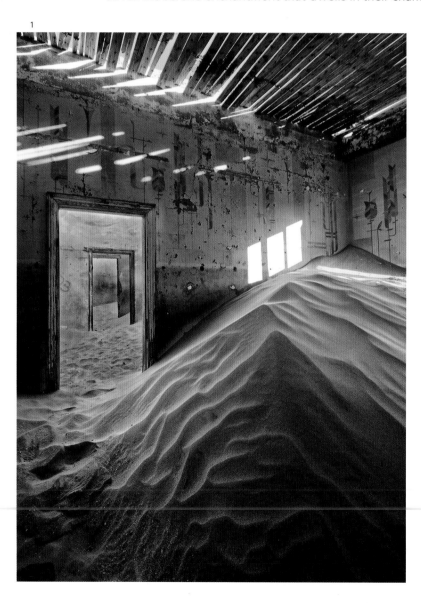

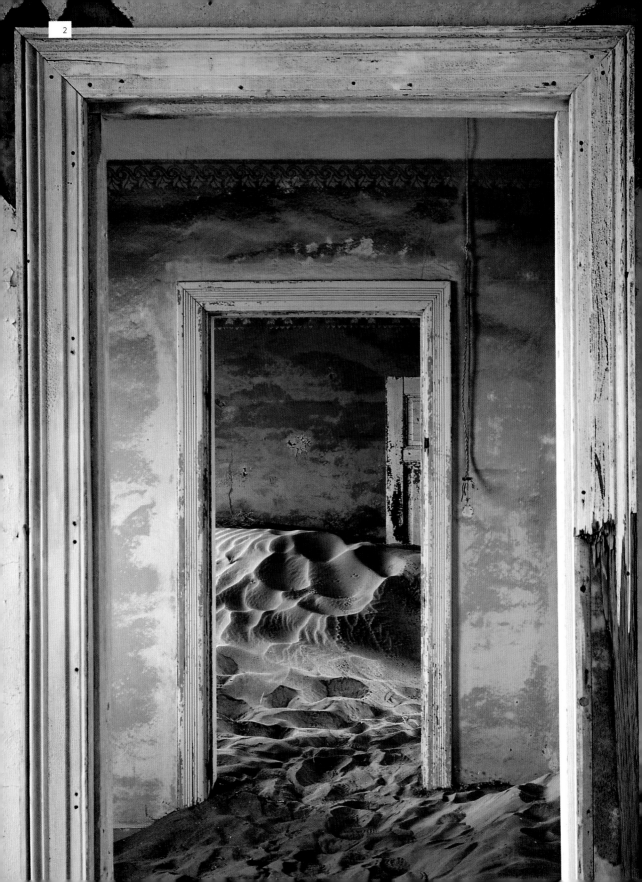

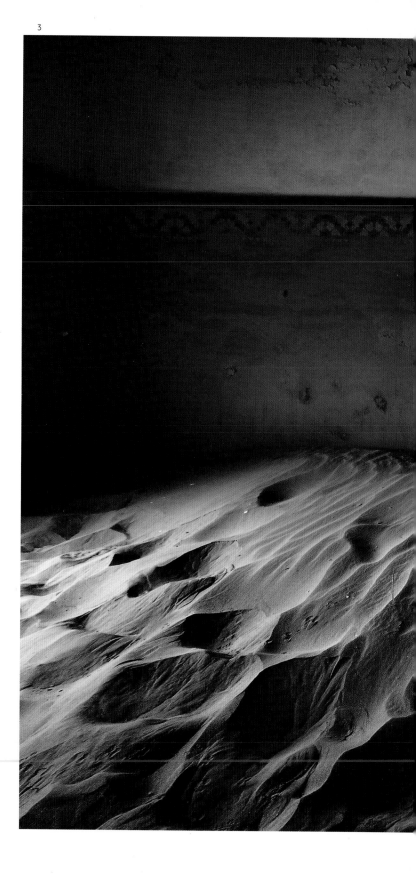

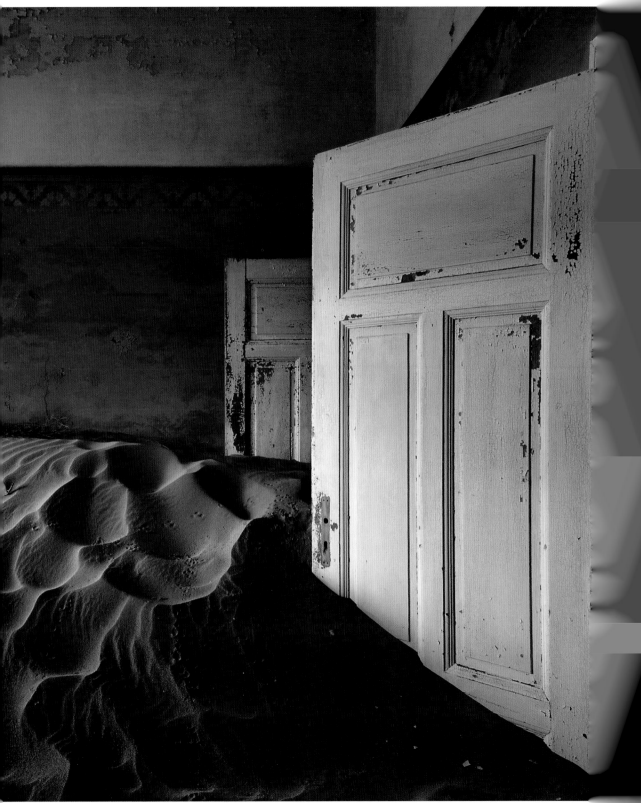

MARY SIBANDE

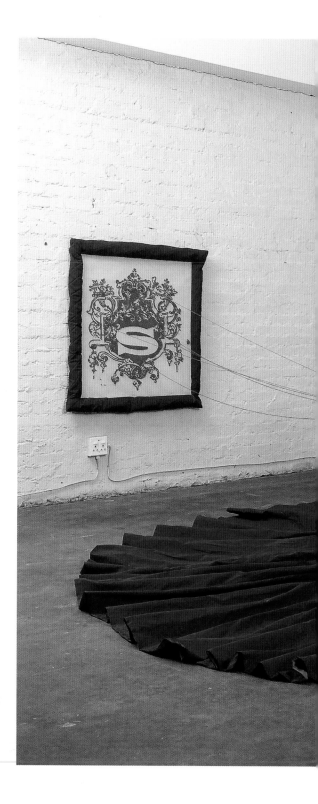

Sibande has been working with a character, or alter ego, named Sophie. This character, a domestic worker, is always dressed in large, extravagant costumes that reflect the style of the imagined Victorian era. She is a contemporary figure who deals with advancing herself. Sibande is not looking at the negatives of being a domestic worker, but rather the humanity and commonalities of people despite the boxes we find ourselves in within the context of post-apartheid South Africa. The modern fabric of Sophie's dress is molded into many forms and combined with Victorian references, making the pieces completely foreign but Sophie's own. By subverting the simple maid's uniform in the creation of Sophie's hybrid dress, she and it become the canvas for storytelling.

Wish you were here, 2010
Mixed media installation
Sculpture: 142 cm × 102 cm × 102 cm
Diameter of red ball: 75 cm × 75 cm × 75 cm
Embroidered tapestry: 105 cm × 112 cm
Diameter of dress: 3.5 m

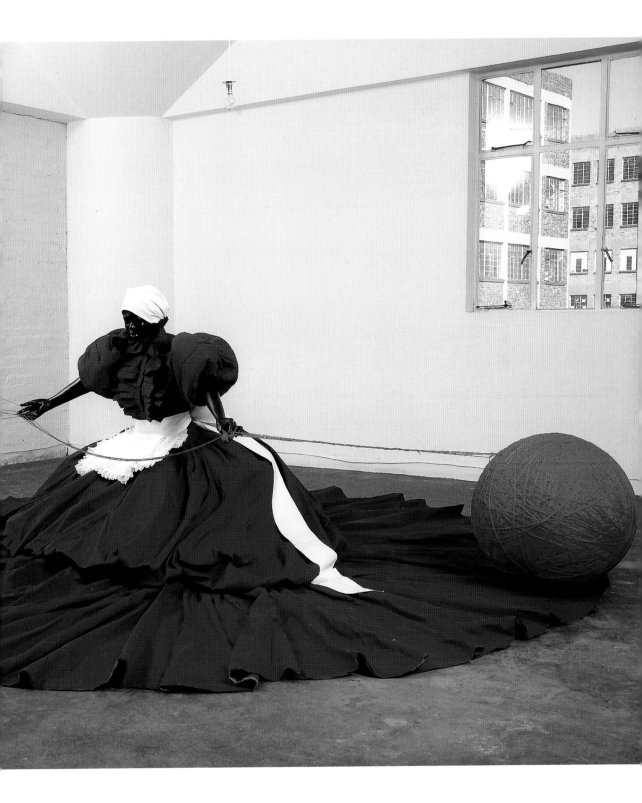

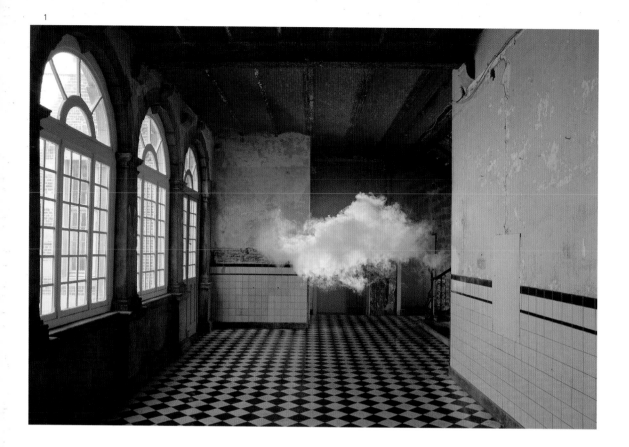

ᛒERNDNALIT SMILDE

The *Nimbus* works present a transitory moment of presence in a specific location. They can be interpreted as a sign of loss or becoming, or just as a fragment from a classical painting. People have always had a strong metaphysical connection to clouds and through time have projected lots of ideas on them. Smilde is interested in the temporary aspect of the work. It is there for a few seconds before it falls apart again. The physical aspect is important, but the work in the end only exists as a photograph. The photo functions as a document.

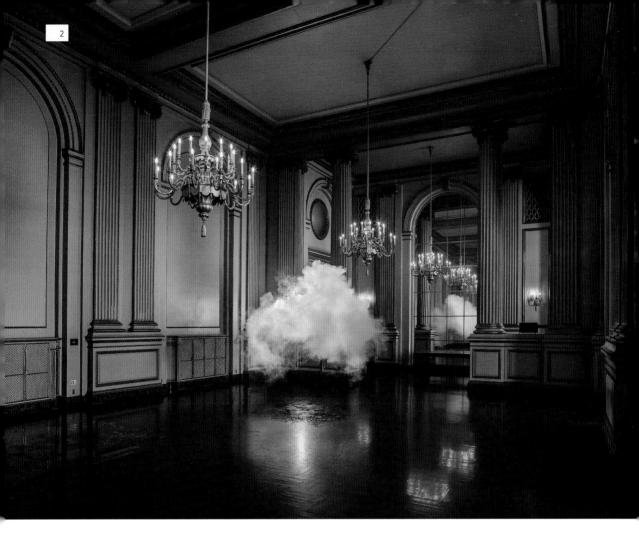

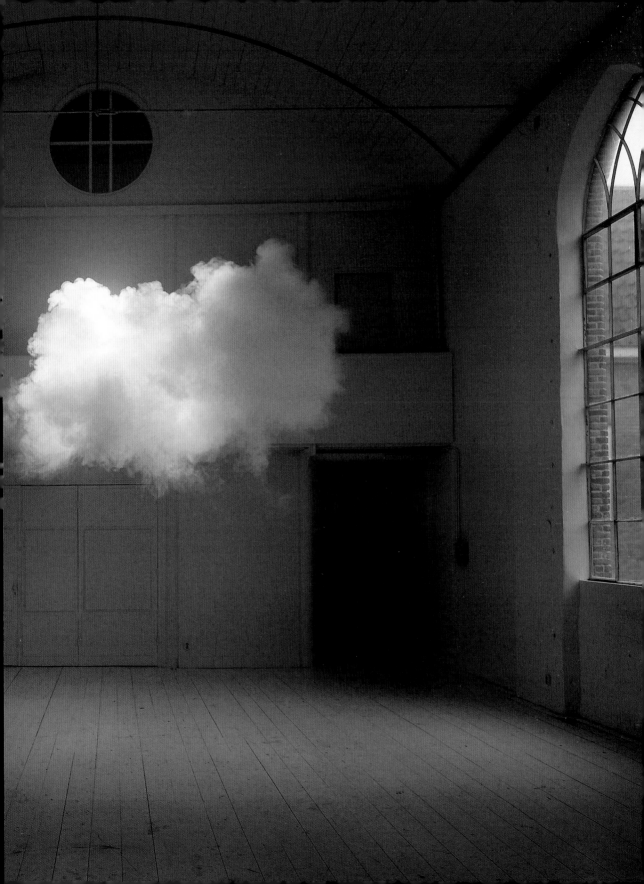

GERDA
STEINER &
JÖRG
LENZLINGER

The Doge of Venice (Mocenigo) needed
a church so as to be able to have a
monumental tomb built for himself, the
church (San Staë) needed a saint so as
to be able to be built, the saint (San
Eustachio) needed a miracle so as to be
pronounced a saint, the miracle needed
a stag in order to be seen, and we built
the garden for the stag. The visitors lie
on the bed above the doge's gravestone,
and the garden thinks for them.

1–4
Falling Garden, 2003
San Staë Church on the Canale Grande,
50th Biennial of Venice, 2003
Components: Plastic berries (India), cow pads (Jura), waste
paper (Venice), baobab seeds (Australia), beech, elder, and
magnolia branches (Uster), thorns (Almeria), nylon blossoms
(one-dollar shop), pigs' teeth (Indonesia), seaweed (Seoul),
orange peel (Migros shop), fertilizer crystals (home grown),
pigeons' bones (San Staë), silk buds (Stockholm), cattail
(Ettiswil), cats' tails (China), celery roots (Montreal), virility rind
(Caribbean), wild boar quills (zoo), banana leaves (Murten),
rubber snakes (Cincinnati) . . .

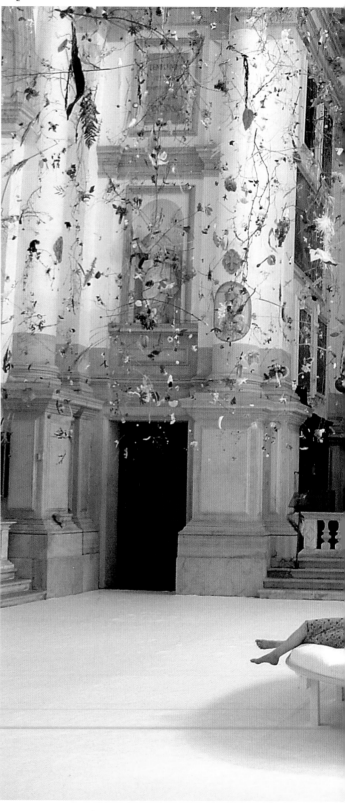

2

1

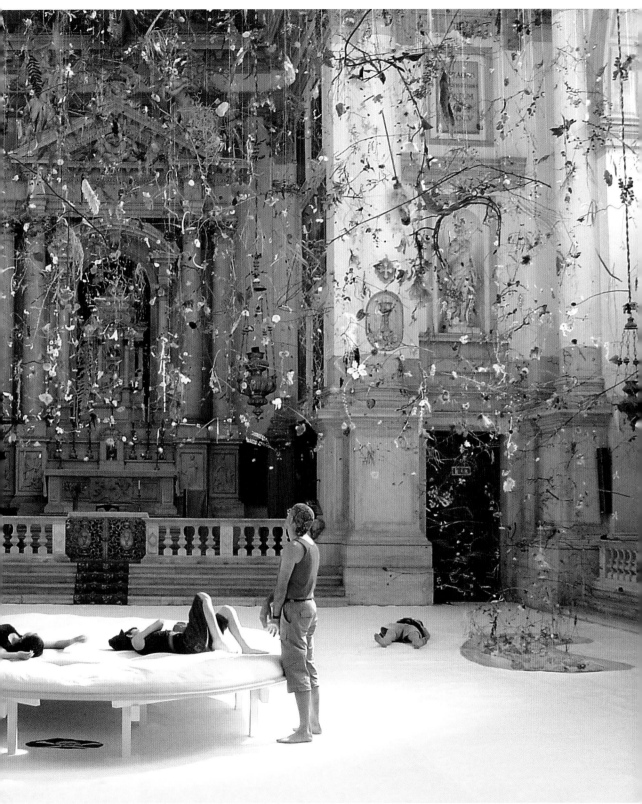

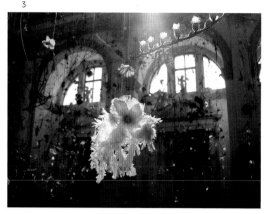

3

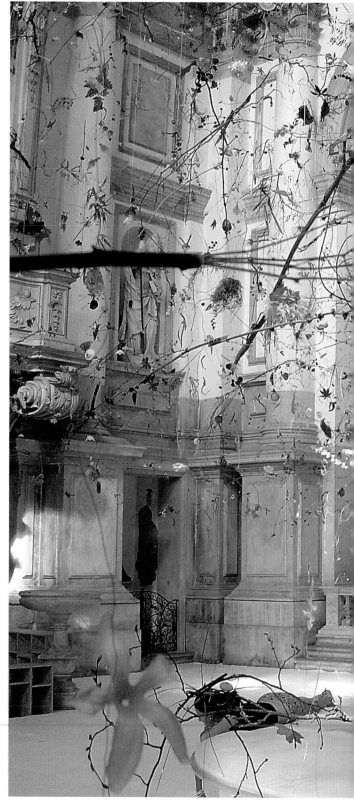

4

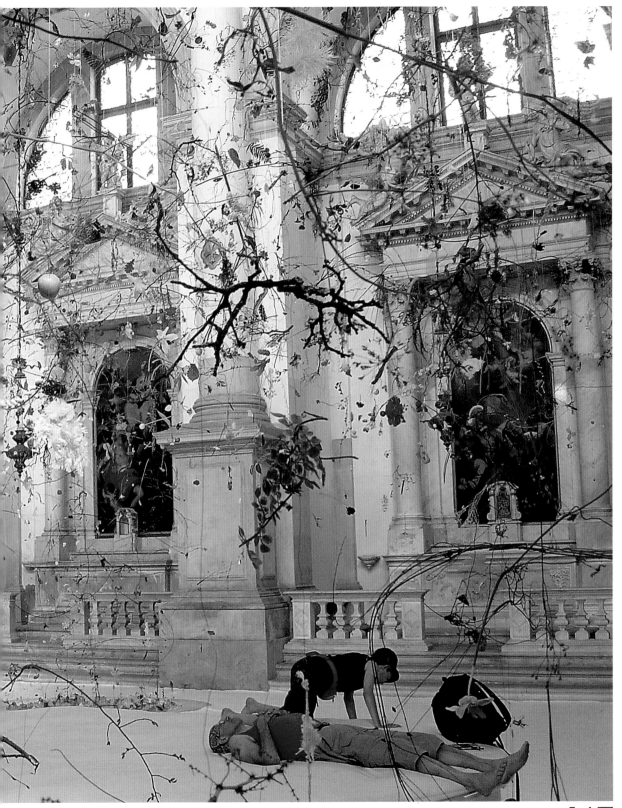

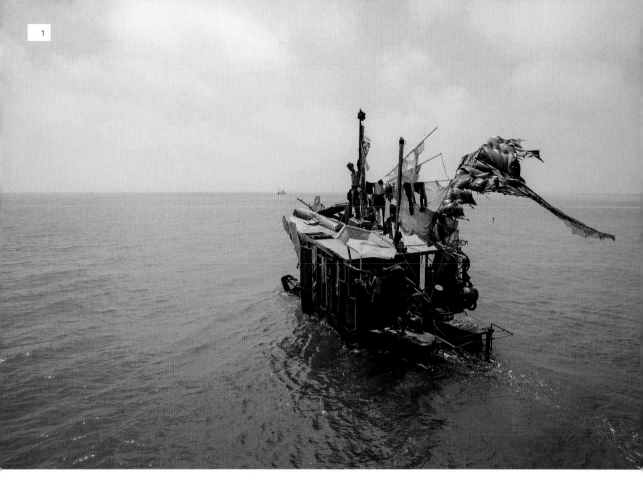

SWOON

1–4
***Swimming Cities of Serenissima*, 2009**
Venice
Mixed media, found objects, wood, tin, metal

In the spring of 2009, I organized a crew of more than thirty friends and collaborators to build a series of three junk rafts, which would navigate the Adriatic Sea toward Venice. The rafts were all built from scavenged materials from New York City, as well as Ankaran, Slovenia, where this journey began.

The rafts, imagined as bits of fantastical cities, broken off and floating out to sea, returned finally, to the mother of fantastical cities rising from the sea—Venice, otherwise known as *La Serenissima*. We docked and performed for two weeks in Venice, making lots of mischief with the Venetian Coast Guard, and a little with the Biennale. Having been denied permission to enter the Grand Canal by police, the Coast Guard, and the mayor of Venice, we decided to take to the canal illegally in the middle of the night, and, to our wonderment and surprise, we were able to navigate successfully until sunrise.

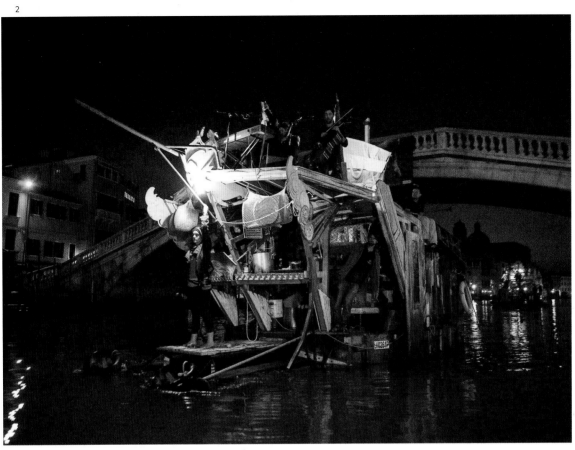

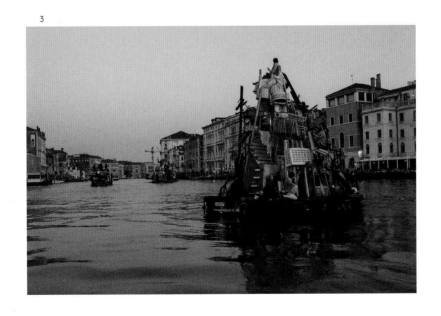

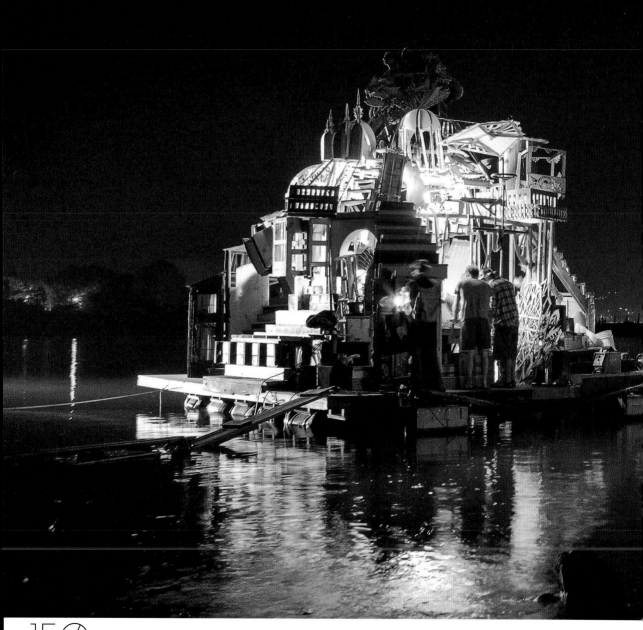

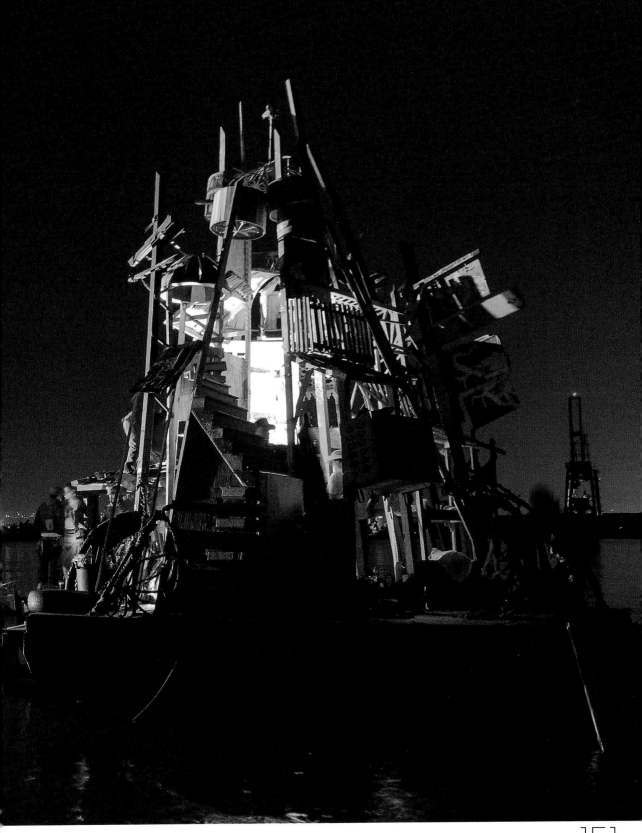

LEONID TISHKOV

1

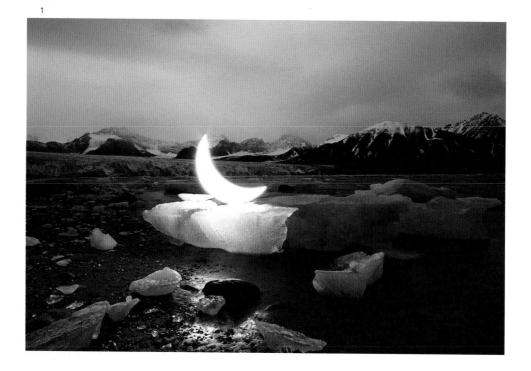

1
***Private Moon in the Arctic*, 2010**
The Moon in front of Monaco Glacier.
Liefdefjorden, Svalbard Archipelago, Norway

2
***Private Moon*, 2003**
Wooden bridge in Peredelkino village,
near Moscow, Russia

3
***Private Moon*, 2011**
The Moon in front Rangitoto volcanic Island,
the Hauraki Gulf near Auckland, New Zealand

Private Moon is a visual poem telling the story of a man who met the Moon and stayed with her for the rest of his life. In the upper world, he saw the Moon falling from the sky. After she hid from the Sun in a dark and damp tunnel, she came to this man's house. When she got well, he took her in his boat across the dark river to a high bank overgrown with moon pine trees. He descended into the lower world and then returned with his personal Moon lighting the path. Crossing the borderline between the two worlds, immersed in a dream and taking care of this heavenly creature, the man became a mythological being. Each photograph is a poetic tale, a little poem in its own right.

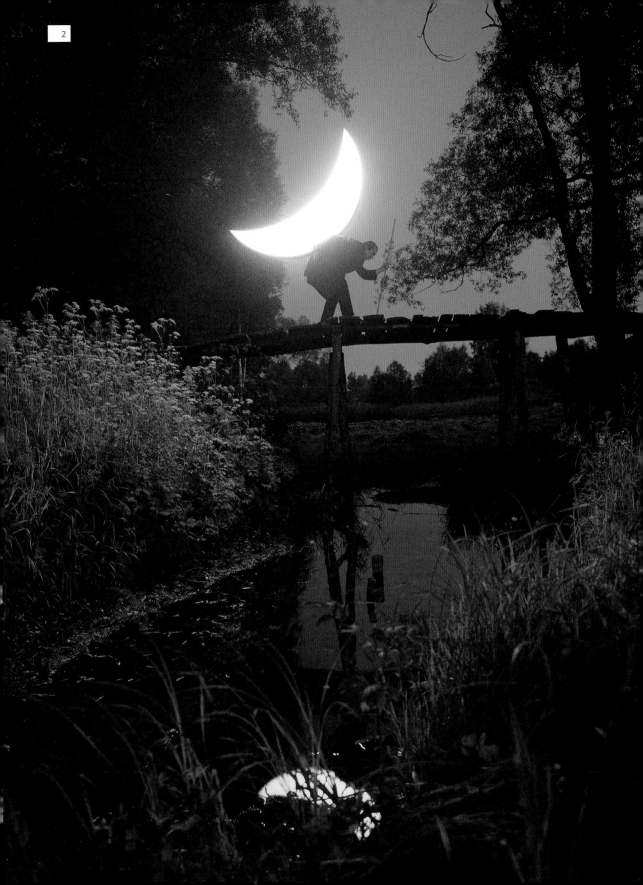

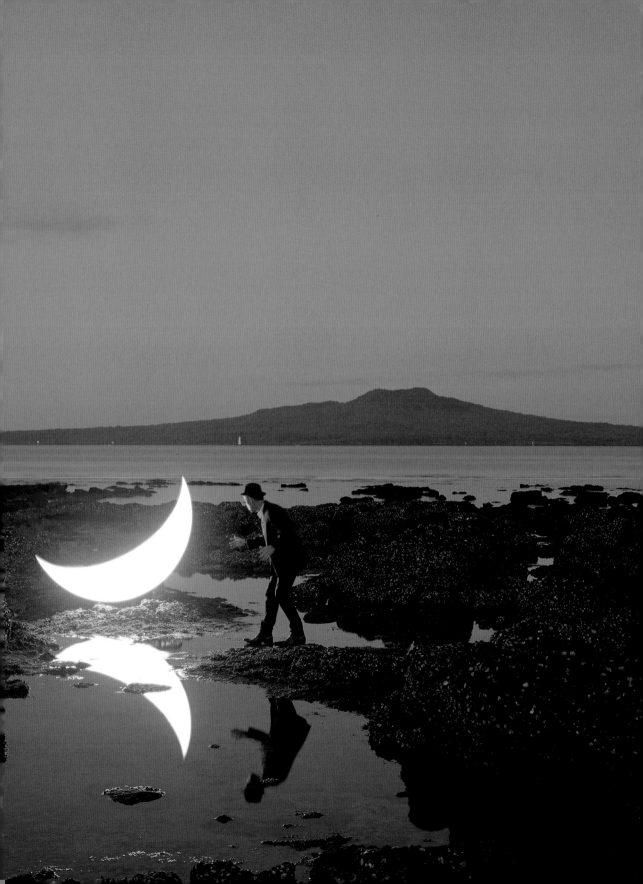

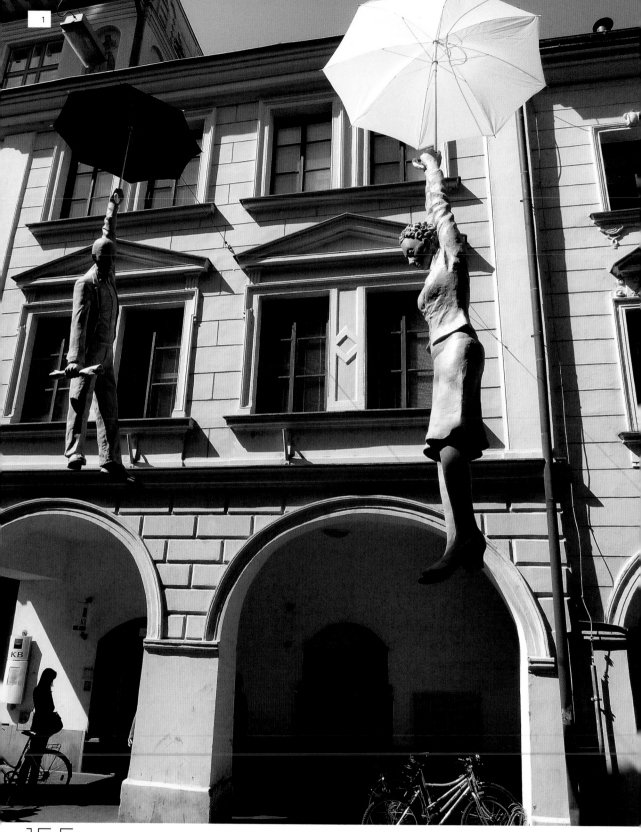

MICHAL TRPÁK

1
Slight Uncertainty II, 2013
České Budějovice
Fiberglass
4 m

2
Slight Uncertainty, 2012
Fiberglass
80 cm × 160 cm

Slight Uncertainty originally hung behind office windows, and then I created a larger version for a public exhibition in České Budějovice. The first sculptures hung in a gap between an old street facade and a new facade of a house that was built about two meters behind the original facade of an old house that had been demolished. In public space, the artist has to think about the scale, the relationship between the architecture and my piece. If the installation is good, both the piece and the space benefit from the relationship. This is the dialog I seek with my art, a discussion among the piece, the architecture, and the people. I named this piece *Slight Uncertainty*—slight because of the seeming lightness of flying, and uncertain because, How long will the flight last? Where does one land?

2

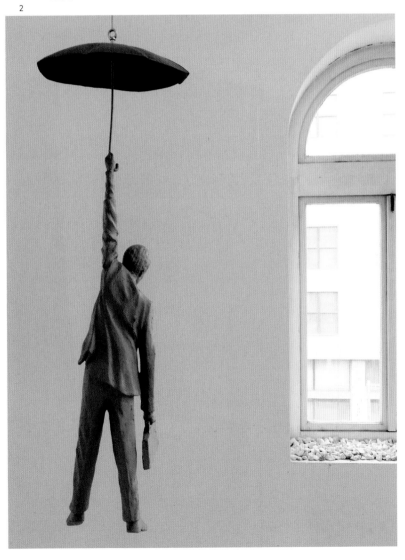

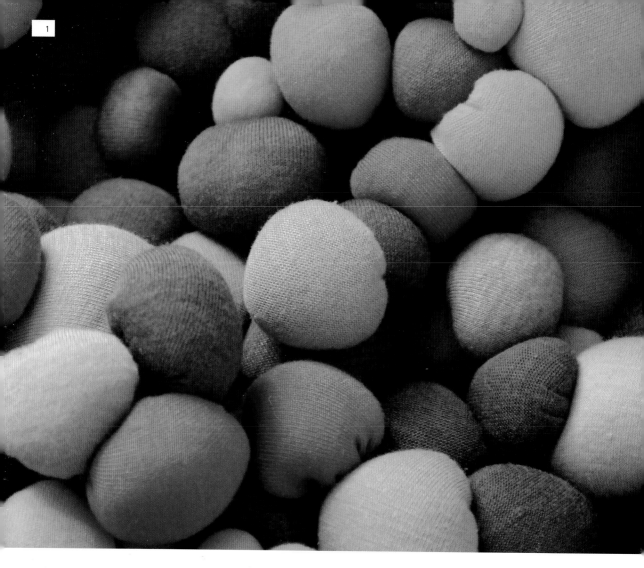

SERENA GARCIA DALLA VENEZIA

1–2
Accumulation, Order, and Chaos, 2011
Textiles
Approximately 4 m tall

This installation resulted from nine months of sewing. The objective was to appreciate how much can accumulate over a given period of time. Throughout the sewing, the piece grew to 157 inches high. The central themes are accumulation and excess, not only in color and shape, but the way in which the work grew and invades both itself and the space around it. *Accumulation, Order, and Chaos* represents the growth patterns of some items in nature: plants, fungus, microorganisms. In growing outward, they adapt to and modify their spaces at the same time.

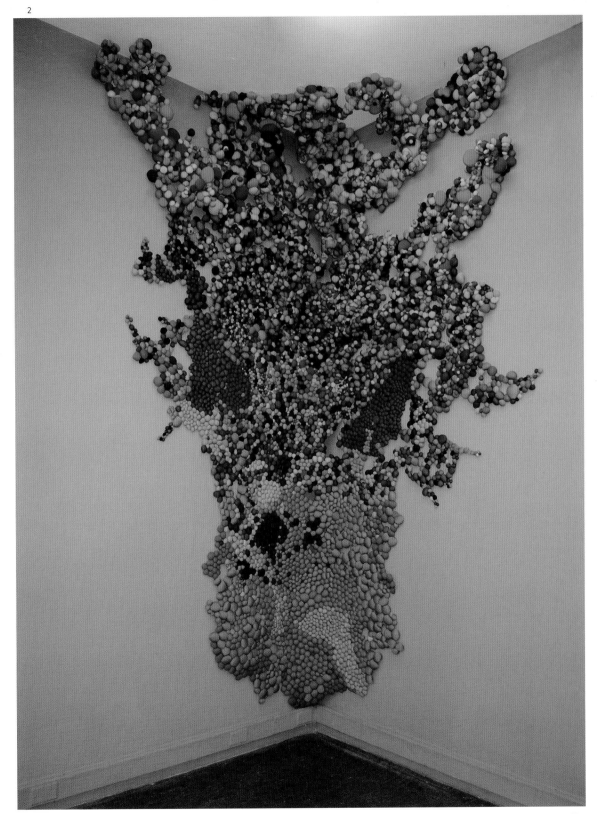

PHOEBE WASHBURN

1

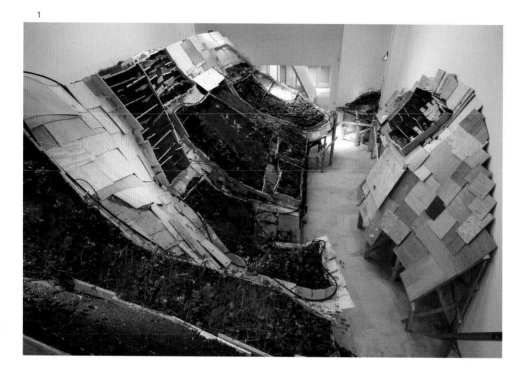

It Makes For My Billionaire Status (2005) is an installation that includes live plants and weeds fastened among found scraps of wood and 2×4s. The installation is built using organizational and categorical systems that the artist sets for herself at the beginning of the building process. The systems develop names, have their own duties, and spawn new systems leading to a controlled but sprawling fractal of debris.

1–5
It Makes For My Billionaire Status, 2005
Kanton/Feuer Gallery, Los Angeles
Mixed media
Overall dimensions variable

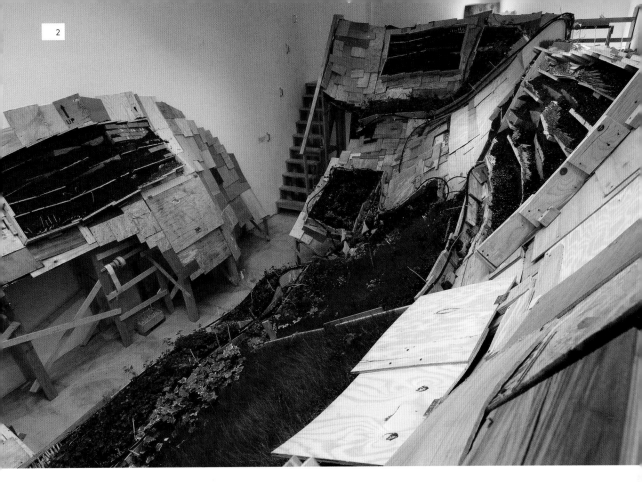

3

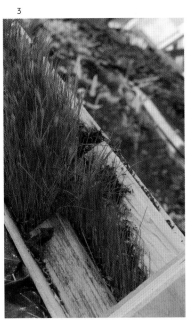

4

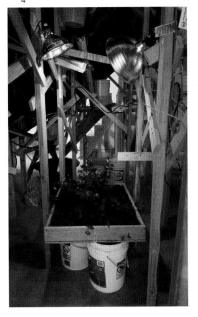

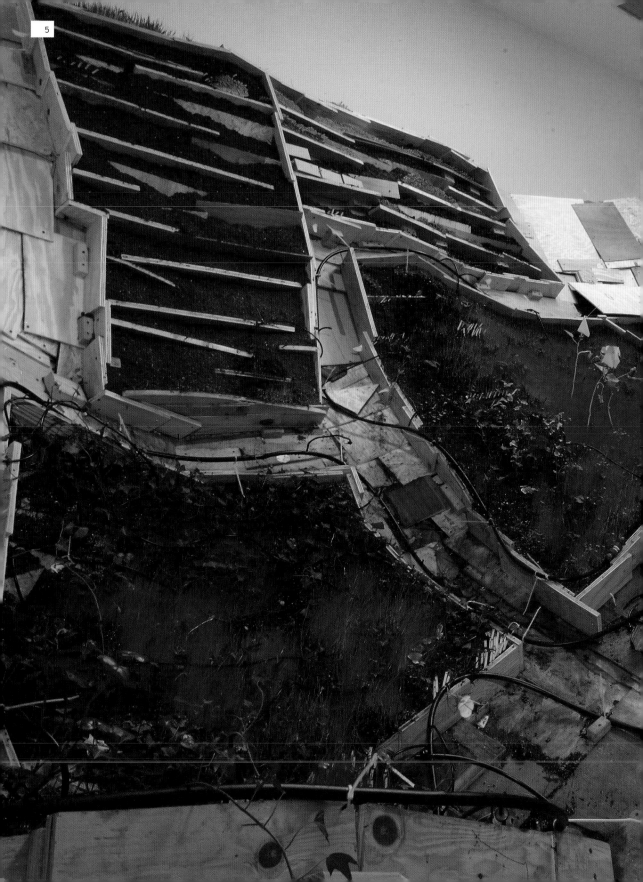

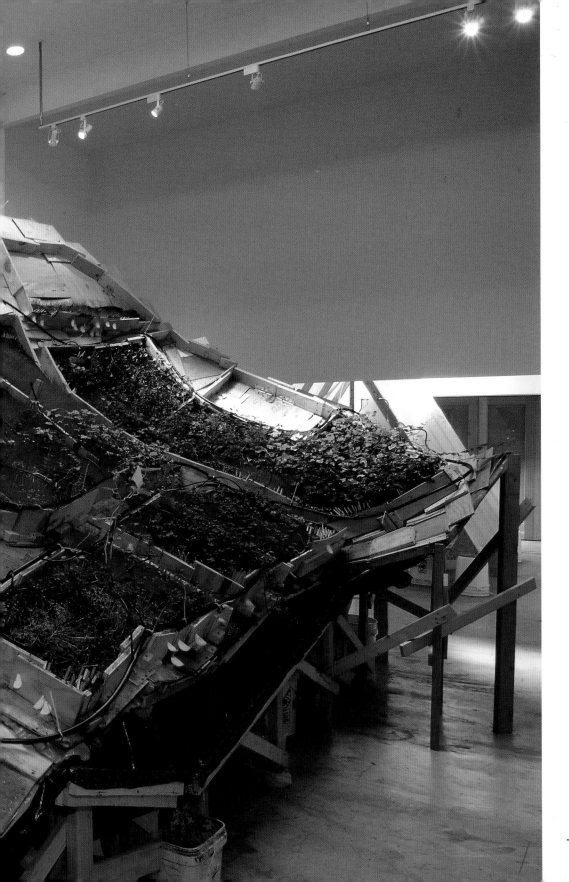

ARTIST BIOS

Adel Abdessemed, born in 1971, studied at the École des Beaux-Arts de Batna and the École des Beaux-Arts d'Alger, Algiers (1987–1994), before traveling to France, where he attended the École nationale supérieure des Beaux-Arts de Lyon (1994–1998). He was an artist-in-residence at the Cité Internationale des Arts de Paris in 1999–2000, and the following year at P.S.1 Contemporary Art Center's International Studio Program in Long Island City, in Queens, New York City. In 2012, his work was the subject of a major solo exhibition at Centre Georges Pompidou in Paris, *Adel Abdessemed Je suis innocent*, which was accompanied by a fully illustrated catalogue published by the museum and Steidl. Now based in Paris and New York, the artist has also lived and worked in Berlin.
→ www.davidzwirner.com/artists/adel-abdessemed

Tanya Aguiñiga (born 1978) is a Los Angeles–based designer and artist who was raised in Tijuana, Mexico. She holds an MFA in furniture design from the Rhode Island School of Design. She created various collaborative installations with the Border Arts Workshop, an artists' group that engages the languages of activism and community-based public art. She founded the group Artists Helping Artisans, through which she helps spread knowledge of craft by collaborating with traditional artisans. Her work has been exhibited from Mexico City to Milan. She is a United States Artists Target Fellow in the field of Crafts and Traditional Arts, a GOOD 100 2013 Recipient, and has been the subject of a cover article for *American Craft* magazine and included in PBS's *Craft in America* series.
→ www.aguinigadesign.com

Ball-Nogues Studio is an integrated design and fabrication practice operating in the territory between architecture, art, and industrial design. The studio has exhibited at major institutions throughout the world, including the Museum of Contemporary Art, Los Angeles; the Museum of Modern Art; the Guggenheim Museum; PS1; the Los Angeles County Museum of Art; arc en rêve centre d'architecture + Musée d'Art Contemporain de Bordeaux; the Venice Biennale; the Hong Kong-Shenzhen Biennale; and the Beijing Biennale. It has received numerous honors, including three American Institute of Architects Design Awards, United States Artists Target Fellowships, and a grant from the Graham Foundation for Advanced Studies in the Fine Arts.
→ www.ball-nogues.com

Robert Barta was born in 1975 in Prague, and now lives and works in Berlin. He holds degrees from the Academy of Fine Arts, Munich, and the San Francisco Art Institute. He has mounted solo exhibitions in Berlin, Rome, and Istanbul, among others, and participated in group exhibitions throughout Europe and in the United States. His works appear in private collections in Belgium, France, Italy, and the United States.
→ www.robertbarta.de
→ www.furiniartecontemporanea.it

Amanda Browder, born in Missoula, Montana, in 1976, received an MFA/MA from the University of Wisconsin at Madison and taught at the School of the Art Institute of Chicago. She currently lives and works in Brooklyn, New York, producing large-scale fabric installations for building exteriors and other public sites. She has shown on three continents, including at the Nuit Blanche Public Art Festival/LEITMOTIF in Toronto; FAB Fest, New York City; The Dumbo Arts Festival, Brooklyn; Mobinale, Prague; Allegra LaViola Gallery, New York City; Nakaochiai Gallery, Tokyo; White Columns, New York City; and No Longer Empty, Brooklyn. Photos and reviews of her work have appeared in print media from the *New York Times* to *Fibers* magazine, and she is a founder of, and can be heard on, the art podcast, www.badatsports.com.
→ www.amandabrowder.com

Nick Cave is a messenger, artist, and educator working between the visual and performing arts through a wide range of media inclusive of sculpture, installation, video, sound, and performance. His solo exhibitions have expanded globally from the United States through France, Africa, Denmark, Asia, South America, and the Caribbean. He has been described as a Renaissance artist and says of himself, "I have found my middle and now . . . working toward what I am leaving behind." Cave also works as a professor at the School of the Art Institute of Chicago. He received his MFA from Cranbrook Academy of Art and his BFA from the Kansas City Art Institute. Cave has earned multiple major awards and honors and his editorial coverage continues to explode worldwide.
→ www.jackshainman.com/artists/nick-cave/

Jenny Chapman and Mark Reigelman
Jenny Chapman is interested in the overlapping boundaries between architecture, infrastructure, art, and design. She believes that designed objects in the world exist

along a continuum and endeavors to erode the established barriers between the various design disciplines. Jenny finds inspiration and happiness in the examination of all objects and their origins. Her art practice is an investigation of site, use, and history. Jenny Chapman lives and works in Seattle.
→ www.unofficialoffice.com

Mark Reigelman's installations deal in the remarkable. Whether it be the materials he uses, their head-turning scale, or their placement in public spaces, his works marry wit, context, and the element of surprise. He approaches each site without any preconceived notion of what should exist, and through meticulous research and exploration of each location's history, physical characteristics, and function, Reigelman creates unique site-specific objects and installations. Reigelman lives and works in Brooklyn, New York.
→ www.markreigelman.com

Miguel Chevalier was born in Mexico in 1959. He has been living in Paris since 1985. Since 1978, Chevalier has focused exclusively on computers as an artistic means of expression. He quickly secured a spot on the international scene as a pioneer of virtual and digital art. His inspiration lies in the history of art and his work explores recurrent themes such as nature and artifice, flows and networks, virtual cities and ornate designs. In the 1980s, Chevalier began tackling the question of the hybrid and generative image.
→ www.miguel-chevalier.com

Michel de Broin has developed a constantly expanding visual vocabulary, with work ranging from assemblage to video and photography. Piece by piece, the objects involved are sometimes universally recognizable, but their behavior defies their functions and uses that are taken for granted. Crafting new relationships among waste, productivity, risk, and consumption, established modes of signification are endangered, yielding retooled technological environments that feed a constant questioning.
→ http://micheldebroin.org

Patrick Dougherty was born in Oklahoma but grew up in North Carolina, where he roamed the woods as a child. As an adult, he combined his carpentry skills with his love of nature and began to learn about primitive techniques of building and to experiment with tree saplings as construction material. Beginning about 1980 with small works fashioned in his backyard, he quickly moved from single pieces on conventional pedestals to monumental site-specific installations that require sticks by the truckload. To date, he has built more than 240 such massive sculptures all over the world. His home is his handmade house of logs outside Chapel Hill, North Carolina, where he lives with his wife, Linda, and son, Sam.
→ www.stickwork.net

Suzan Drummen works in the media of painting, photography, installation, and public art. She prefers to work on site-specific installations and on a large scale. Her works are a playful investigation of space, illusion, optical effects, and other visual phenomena as part of a broad exploration of visual perception and the limits of beauty. In the works, there is an ongoing inquiry into the limits of seduction and repulsion.
→ www.suzandrummen.nl

Alejandro Durán is a Mexican-born, New York–based multimedia artist working in photography, installation, video, and poetry. Durán received En Foco's New Works Award in photography and has exhibited his work at the Bronx Biennial of Latin American Art and the Galería Octavio Paz at the Mexican consulate in New York. Durán is also the founder of The Digital Project, a video production company focused on culture and education, with clients including MoMA, the Museum of Arts & Design, and Columbia University.
→ www.alejandroduran.com

Janet Echelman builds living, breathing sculpture environments that respond to the forces of nature—wind, water, and light—and become inviting focal points for civic life. Exploring the potential of unlikely materials, from fishing net to atomized water particles, Echelman combines ancient craft with cutting-edge technology to create her permanent sculpture at the scale of buildings. Experiential in nature, the result is sculpture that shifts from being an object you look at, to something you can get lost in. A recipient of a Guggenheim Fellowship, Echelman was named a 2012 Architectural Digest Innovator for "changing the very essence of urban spaces." Her TED talk "Taking Imagination Seriously" has been translated into thirty-four languages and is estimated to have been viewed by more than a million people worldwide.
→ www.echelman.com

Leandro Erlich (born 1973, Argentina) lives and works in Buenos Aires. He began his career in the United States (Houston, New York), moved to Paris for a few years, and returned to Buenos Aires. He has participated in many art biennales (like Whitney, Venice, Saõ Paulo, Istanbul, Echigo-Tsumari) and had his work exhibited in great museums of the world including P.S.1 MoMA (NY), Centre Georges Pompidou and Palais de Tokyo (Paris), Museo Nacional Reina Sofía (Madrid). His works are in private and public collections, including Tate Modern, Musée d'Art Moderne (Paris), 21st Century Museum of Art, and Kanazawa.
→ www.leandroerlich.com.ar

Christine Finley is known for her vibrant geometric paintings and site-specific public art installations. Her Wallpapered Dumpsters project has been featured in

the *New York Times*, the *Huffington Post*, CNN.com, *NYLON* magazine, *Dazed*, and the BBC World Service, Brazil. Finley has shown internationally with exhibitions at Galerie Ernst Hilger, Vienna; Robert Fontaine Gallery, Miami; Scope Miami and New York; FDA Projects, Rome; and the Dumba Collective, New York, among others. In 2012, Finley was the artist-in-residence at the Gai Mattiolo fashion house in Rome, Italy. As the recipient of the Eszter Cohen Grant, Finley continues to wallpaper dumpsters in cities throughout the world. Finley received her BFA from the Pratt Institute in New York and her MFA from California State University, Long Beach. Finley lives in Rome and New York.
→ iamfinley.com

FriendsWithYou is the fine-art collaborative of Samuel Borkson and Arturo Sandoval III, working collectively since 2002 with the sole purpose of spreading the positive message of Magic, Luck, and Friendship™. As artists working in a variety of media, including paintings, sculpture, large-scale experiential installations, public playgrounds, published works, and live performances, FriendsWithYou's mission is to affect world culture by cultivating special moments of spiritual awareness and powerful, joyous interaction. FriendsWithYou's work has been exhibited at the High Line in New York City, Art Basel Miami Beach, Galerie Emmanuel Perrotin, the Indianapolis Museum of Art, Haus der Kulturen der Welt Museum in Berlin, and the Santa Barbara Contemporary Arts Forum, among others. FriendsWithYou actively works to spread the message of connectivity around the world, with a simple mission to become Friends-With-You.
→ www.friendswithyou.com

Joost Goudriaan (bio by Hidde van Schie)
The interventions of this young Rotterdam artist are a humorous critique on problems of ownership in the public domain. By transforming the look of dustbins, potholes, and park benches, he questions our relationship with and treatment of these objects. While investigating underlying assumptions about the user in the design of anonymous government infrastructure, he reveals our exaggerated respect for privately owned luxury goods.
→ www.joostgoudriaan.nl

Ann Hamilton is a visual artist internationally recognized for her large-scale installations and related video, objects, and prints. In 2012, Hamilton premiered a major new work titled *the event of a thread* at the Park Avenue Armory in New York. She has been awarded a MacArthur Fellowship, Guggenheim Memorial Fellowship, NEA Visual Arts Fellowship, United States Artists Fellowship, and the Heinz Award. Her major museum installations include the Solomon R. Guggenheim Museum; Pulitzer Foundation for the Arts; Contemporary Art Museum, Kumamoto; La Maison Rouge Fondation de Antoine Galbert; MASS MoCA; The Hirshhorn Museum and

Sculpture Garden; The Museum of Modern Art; The Tate Gallery; and the Dia Center for the Arts. She is a Distinguished University Professor in the Department of Art at Ohio State University.
→ www.annhamiltonstudio.com

Lynne Harlow is a reductive artist based in Providence, RI. Born in Massachusetts in 1968, she makes large scale site-specific work as well as drawings and prints in a language of sensual minimalism. She holds an MFA from Hunter College in New York. Her work is exhibited in the U.S. and internationally, and is held in numerous collections including those of The Metropolitan Museum of Art and The RISD Museum of Art. In 2011 she was awarded the Robert and Margaret McColl Johnson Fellowship of the Rhode Island Foundation, a $25,000 merit award supporting development of new work, and in 2002, she was a visiting artist at the Chinati Foundation in Marfa, Texas.
→ www.lynneharlow.com

HENSE, native to Atlanta and known initially for name recognition as a graffiti artist, is an award-winning public artist whose nearly two decades of working in the realm of public art, grants, commissions, and cross-media connections have landed him local, national, and international public art projects. HENSE began his career painting and writing on walls in and around Atlanta. When Atlanta passed an antigraffiti law in 2003, HENSE moved into the realm of granted and commissioned public art. Combining the language and techniques of graffiti art with the formal language of abstract painting, HENSE has produced artworks that incorporate line, shape, and gesture to create abstract compositions that are invigorated by the quick pace and commentary of street culture. HENSE currently lives and works in Atlanta.
→ hensethename.com

Florentijn Hofman's (born 1977, Delfzijl, Netherlands) hallmarks are humor, sensation, maximum impact; the internationally renowned artist does not settle for less. His sculptures are large—very large—and are bound to make an impression. Hofman's sculptures often originate from everyday objects. A straightforward paper boat, a pictogram of an industrial zone, or mass-produced little toy figures all serve as sources. They are all readymades, selected by Hofman for the beauty of their forms. An encounter with one of Hofman's extraordinary sculptures invites us to stand still for a moment and to look—to really look and to take a picture if you like.
→ florentijnhofman.nl

HOTTEA
The concept behind my work is nondestructive street art. I predominantly use yarn for all of my works, with the addition of other materials if it suits the space. My goal is to evoke the imagination within us all. As we grow older, we often lose child-like innocence and creative

imagination. For those who keep creativity going, sometimes spaces may seem a bit lifeless. For those who have grown out of it or do not tap into it as much, we accept our surroundings and do not think of them creatively. I want to inspire imagination in all of us. With the use of color and space, I bring the viewer an experience they can only have in that space.

Gyun Hur has performed and exhibited in Atlanta, New York City, Chicago, Seattle, Hong Kong, and Turkey. Gyun's work has been widely recognized for her floor installations comprised of hand-shredded silk flowers that evoke a sense of labor, loss, and memories. Gyun is the recipient of the Hudgens Prize (2010), Artadia Award (2011), and Joan Mitchell Foundation Scholarship (2010). Her works have been featured in *Art In America*, *Art Papers*, *Sculpture*, the *Atlanta Journal-Constitution*, *Pelican Bomb*, *Creative Loafing*, *Jezebel*, and *The Atlanta*. Her interest in art making in public space led her to various artist presentations and projects with the TEDxCentennialWomen, the international street art conference Living Walls: The City Speaks, gloATL's Hippodrome, and many others. She currently lives and works in Hong Kong.
→ gyunhur.com.

Institute For Figuring is a nonprofit, Los Angeles–based organization dedicated to the poetic and aesthetic dimensions of science and mathematics. The IFF pioneers creative new methods for engaging the public about scientific issues by putting people and communities at the core. Cofounded by science writer Margaret Wertheim and her sister Christine Wertheim, a member of the critical studies faculty at California Institute of the Arts, the IFF specializes in creating participatory projects in which communities build large-scale artworks inspired by discoveries and techniques stemming from scientific and mathematical research. The IFF has created exhibitions and programming for many institutions worldwide including the Andy Warhol Museum (Pittsburg), the Hayward Gallery (London), the Science Gallery (Dublin), and the Smithsonian's National Museum of Natural History (Washington, D.C.).
→ www.theiff.org

Kaarina Kaikkonen, one of Finland's leading artists, is known internationally for her large-scale, site-specific environmental installations made from simple recycled materials and domestic items such as clothing or shoes and toilet paper. She has created works for art venues and projects across the world. She has participated in numerous international exhibitions, including the EchigoTsumari Triennale in Japan 2006, Cairo Biennale 2009, the Liverpool Biennale 2010, the Vancouver Biennale 2010, and in the Venice Biennale collateral event, 2011. In 2013, Kaarina completed projects in Santiago, Chile; in Washington, D.C.; in Brighton, U.K.,

in Shanghai China; and in the first Arezzo Biennale in Italy, where she won the main prize, the Golden Chimera.
→ kaarinakaikkonen.com

Erik Kessels (1966) is a founding partner and creative director of KesselsKramer, an independent international communications agency located in Amsterdam, London, and Los Angeles. Kessels works for national and international clients and has won numerous awards. He has published several books of vernacular photography through KesselsKramer Publishing, including the *in almost every picture* series. Since 2000, he has been one of the editors of the alternative photography magazine *Useful Photography*. He has taught at the Gerrit Rietveld Academy and at the Amsterdam Academy of Architecture, where he curated a celebration of amateurism. In 2010, Kessels was awarded the Amsterdam Prize of the Arts and in 2012 elected as the most influential creative of the Netherlands.
→ www.kesselskramer.com
→ www.kesselskramerpublishing.com
→ www.kkoutlet.com

Tetsuo Kondo Architects was established in 2006 by the architect Tetsuo Kondo. Kondo was born in 1975 in Ehime, Japan. He graduated from the Nagoya Institute of Technology in 1999 and worked at Kazuyo Sejima and Associates (SANAA) from 1999 to 2006. The main projects by Tetsuo Kondo Architects include *House with Gardens* (private house), *Cloudscapes* at the twelfth Biennale di Venezia, the international architecture exhibition *A Path in the Forest* at European Capital of Culture 2011, Urban Installations Festival LIFT11, *House in Chayagasaka* (private house), and *7ip* (*New House Shuppan*, 2013), which is a house in Chayagasaka.
→ www.tetsuokondo.jp

Tomoko Konoike was born in 1960 in Akita, Japan. She freely combines media such as painting, sculpture, animation, illustrated books, and games to create magnificent installations expressing modern myths. She has exhibited at international exhibitions in Korea, Germany, Australia, France, and China, and has mounted solo exhibitions in Japan, Korea, and the United States.
→ tomoko-konoike.com

Cornelia Konrads was born in 1957 in Wuppertal, Germany. She has worked as an artist since 1998, focusing on site-specific sculptures and objects. She has produced commissioned works—both indoors and outdoors, temporary and permanent—for public spaces, sculpture parks, and private gardens. She has participated in various sculpture and land art projects all over the world: Europe, Asia, Australia, North America, and Africa.
→ www.cokonrads.de

Joris Kuipers, born in Nijmegen, Netherlands (1977), studied at the Frank Mohr Institute (MFA, painting) in

Groningen from 2001 to 2003. He now lives and works in Rotterdam. Kuipers's work consists of large (room-filling) installations, sculptures, and collages. He finds inspiration in historic, scientific, and/or anatomic sources ranging from the woodcuts by Andreas Vesalius to CT scans, MRI scans, autopsy images, and Gunther von Hagens's plastinations. As in a medical act, Kuipers dissects the body layer by layer. After this fragmentation, the body is rearranged in a nonrational manner in order to reveal new emotional meaning. His work has been exhibited at art fairs such as Art Amsterdam NL (2009) and Art Gent BE (2011).
→ www.joriskuipers.com

Hitoshi Kuriyama was born in 1979 in Hyogo, Japan. He earned an MFA in constructive art at the University of Tsukuba (2006), and a PhD in intermedia art from Tokyo University of the Arts (2011). In his works, he explores equivalency in conflicting ideas such as existence and nonexistence, or creation and destruction, and demonstrates them from a scientific perspective. He has theorized the hypothesis "0 = 1" and attempts to prove it through his works. He has participated in numerous exhibitions worldwide such as *data and vision* (Aki Gallery, Taipei), *0,1, and visions* (Venice Project, Venice), *GLASSTRESS 2011* (collateral event of the 54th Venice Biennale, Venice), *Drifting Images BODA (Seoul)*, and *What Dwells Inside* (S12 Galleri og Verksted, Bergen, Norway).
→ hitoshikuriyama.blogspot.com

William Lamson is a Brooklyn-based artist who works in video, photography, performance, and sculpture. His work is in the collections of the Brooklyn Museum, the Dallas Museum of Art, the Museum of Fine Arts in Houston, and a number of private collections. Since graduating from the Bard MFA program in 2006, his work has been shown at the Indianapolis Museum of Art, the Brooklyn Museum, P.S.1 MOMA, and the Museum of Contemporary Art Denver, among others. In 2012, he completed two site-specific installations for Storm King Art Center.
→ www.williamlamson.com

Christopher M. Lavery has exhibited both nationally, including at the Museum of Contemporary Art in Denver, the Denver Art Museum, and the Boulder Museum of Contemporary Art, and internationally. In 2008, he was awarded the Emerging Public Artist Project Grant from the Colorado Percent for the Arts at Denver International Airport for his project entitled *Cloudscape*, a monumental-scale project that won an award in 2010 from the Americans for the Arts Public Art Network. Lavery has held a residency at the well-known Vermont Studio Center, where he began to develop a new body of work about the rapidly developing global warming crisis and the melting of the polar icecaps.
→ www.christopherlavery.com
→ www.thecloudscape.com
→ www.christopherlavery.wordpress.com

Myoung Ho Lee's work was included in the exhibition, *Who is Alice?*, organized by the National Museum of Contemporary Art, Korea, which was on view at the Spazio Lightbox during the 2013 Venice Biennale. Lee is the recipient of various awards, including the first Young Photographer's Award from the Photo Artist's Society of Korea in 2005, Korea's Photography Critics Award in 2006, and a grant from the Culture and Art Fund from the Arts Council of Korea in 2007. Lee's work is included in the permanent collections of the J. Paul Getty Museum, Los Angeles, and the National Museum of Contemporary Art, Korea. Lee was born in Daejon, Korea, in 1975 and currently lives and works in Seoul, Korea.
→ www.yossimilo.com/artists/myou_ho_lee/

LILIENTHAL|ZAMORA (Etta Lilienthal and Ben Zamora) are recognized as one of the most important and influential pair of artists emerging from Seattle's vibrant art scene. Individually, each has an impressive history designing internationally for projects in opera, dance, and theater with collaborators including Peter Sellars, Bill Viola, and Emio Greco|PC. As a creative team, their sculptural installation work has been featured at the Suyama Space Gallery, the Coachella Valley Music and Arts Festival, and alongside the Kronos Quartet and Degenerate Art Ensemble. What began as a natural extension of their initial creative partnership in performance design has grown into a body of work that challenges the relationship of viewers to their environment and addresses universal themes of birth, death, and transcendence. Their work is boldly immersive and intimate, placing the viewer inside as an active participant while challenging the perceptive limits of positive and negative space.
→ lilienthal-zamora.squarespace.com

Rafael Lozano-Hemmer, a Mexican Canadian electronic artist, develops large-scale interactive installations that are at the intersection of architecture and performance art. His main interest is in creating platforms for public participation, by perverting technologies such as robotics, computerized surveillance, or telematic networks. Inspired by phantasmagoria, carnival and animatronics, his huge light-and-shadow works are "antimonuments for alien agency." His work in kinetic sculpture, responsive environments, video installation, and photography has been shown in museums in four dozen countries and biennials.
→ www.lozano-hemmer.com

Toshihiko Horiuchi MacAdam was hired by a prestigious interior textile firm in New York after completing her MFA. By age thirty, however, she had decided to live as a self-employed artist, supplementing her income with freelance design work and teaching. She has taught in the U.S., Japan, and Canada, and exhibited her work in museums and galleries around the world. The first public playspace was created for one of Japan's national

parks in 1979. In 1990, she and her husband joined forces, and together they have installed pieces in the U.S., Canada, Japan, China, Korea, Singapore, Spain, and Italy, where their *Harmonic Motion* is installed in Rome's Museum of Contemporary Art. Her published works include a two-volume reference on textile structures, *from a line*. She teaches part-time at NSCAD University in Canada.
→ www.netplayworks.com

Russell Maltz (born 1952, Brooklyn, New York) has exhibited work in numerous solo and group exhibitions throughout the United States and internationally, including in Australia, Germany, Austria, France, Italy, Israel, Denmark, Mexico, Switzerland, Japan, and New Zealand. His work has been reviewed in publications such as The *New York Times*, *Artforum*, *Art in America*, and the *Village Voice*. His works are in multiple collections internationally, including the Brooklyn Museum, Yale University Art Museum, Fogg Art Museum, Harvard University Art Museum, Stiftung fur Konkreter Kunst (Reutlingen, Germany), Wilhelm-Hack Museum (Ludwigshafen, Germany), and the Gallery of Western Australia (Perth, Australia). He has been facilitating with Critical Practices Incorporated since its inception and serves on its advisory board. Russell Maltz lives and works in New York City and is represented by Minus Space.
→ www.minusspace.com/russell-maltz

Marshmallow Laser Feast (MLF) is a London-based creative and artistic studio that produces groundbreaking work at the intersection of art and cutting-edge technology. Founded in 2011 by three multitalented visual artists—Memo Akten, Robin McNicholas, and Barney Steel—MLF's focus is creating emotional and engaging experiences that immerse their audience in a new world. MLF's work ranges from real-time animations, large-scale interactive installations, to live events and performances.
→ http://marshmallowlaserfeast.com

Rowena Martinich is a contemporary abstract expressionist from Melbourne, Australia. Renowned for her use of radiant color and large-scale gestural paintings, predominantly integrated into architectural facades. Martinich has a wide-ranging practice, commissioned to paint walls in sites from Xian Yang in China, Prato in Italy, and Şile in Turkey to Balmoral in remote regional Australia. Martinich chooses not to let her paintings conform to rigid structure; rather, they tend to explode color and energy across whatever surface she is faced with. An example of this is seen in *Common Gesture*, a project that spanned four floors of glass on an inner city building in Melbourne. Other, more recent projects have seen her collaborating with architects to activate new buildings with her distinctive style.
→ www.martinich.com.au

Mademoiselle Maurice, a French artist, was born and raised in the high mountains of Savoy. After studying architecture in Lyon, she spent time in Geneva and Marseilles before spending a year in Japan. After her time in the country of the rising sun, she was greatly moved by the tragic events in 2011 (earthquakes, tsunami, and the nuclear power plant disaster in Fukishima). She decided to begin composing urban works out of plastic as a response to these events. Light in appearance, the work of Mademoiselle Maurice raises many questions about human nature and the interactions that sustain people and the environment.
→ www.mademoisellemaurice.com

Shelley Miller is a Montreal-based artist who works in public spaces, creating both ephemeral street art installations and permanent public art commissions. She has presented her work across Canada as well as India, Brazil, and Australia. She earned her BFA from the Alberta College of Art and Design in 1997 (Calgary) and an MFA from Concordia University (Montreal) in 2001. She has received numerous fellowships and grants from the Canada Council for the Arts, the Conseil des arts et des lettres du Quebec, and the Commonwealth Foundation.
→ www.shelleymillerstudio.com

Mihoko Ogaki was born in 1973 in Toyama, Japan, and graduated from Aichi University of Fine Arts and Music with a degree in oil painting. Ogaki then went on to study sculpture at the Kunstakademie in Dusseldorf, Germany, earning a certificate of sculpture in 2004.
→ www.mihoko-ogaki.com

Kimihiko Okada opened his architecture firm, the Office of Kimihiko Okada, in Tokyo in 2005. They use a working approach based on architectural thinking. Works include a diverse range of products, from architectural design to interior design for house, shops, exhibition space design, product design, and spatial installations.
→ ookd.jp

Soo Sunny Park received her BFA in painting and sculpture from Columbus College of Art and Design in Columbus, Ohio, and an MFA in sculpture from Cranbrook Academy of Art in Bloomfield Hills, Michigan. She is a recipient of a Joan Mitchell MFA Grant, the nineteenth Annual Michigan Fine Arts Competition Grand Prize, the Helen Foster Barnett Prize from the National Academy Museum in New York City, and the Rockefeller Foundation Bellagio Center Fellowship. Her recent solo shows include *Unwoven Light*, Rice Gallery, Houston, Texas; *Capturing Resonance*, DeCordova Sculpture Park and Museum, Lincoln, Massachusetts; and *Soo Sunny Park: Vapor Slide*, Cranbrook Art Museum, Bloomfield Hills, Michigan. Soo Sunny Park lives and works in New Hampshire, where she is associate professor of studio art at Dartmouth College.
→ www.soosunnypark.com

Paola Pivi (born 1971, Milan), nomadic by nature, has lived all over the world, including Shanghai, the remote island of Alicudi in southern Italy, and Anchorage, Alaska. She is presently in India. Pivi first exhibited at Viafarini in Milan in 1995, the same year she enrolled in the Brera Academy of Art in Milan. In 1999, she was co-awarded the Golden Lion for the best national pavilion (Italy) at Harald Szeemann's Venice Biennial. She exhibits internationally, including in the Netherlands, Italy, France, China, and the United States.
→ www.paolapivi.com

Malene Hartmann Rasmussen works in the cross-aesthetic intersection between art, design, and crafts. Graduating from the Royal Danish Academy of Fine Art, School of Design, Bornholm, and the Royal College of Art in London, she now lives and works in London. In addition to numerous exhibitions in the U.K. and Denmark, she has participated in exhibitions in Belgium, Sweden, and Croatia. Rasmussen has been the Artist in Residence/Guest Artist at the International Ceramic Center, Guldagergaard, in Denmark, and has done several public commissions, most recently a sculpture for Ringsted Musik-og Kulturskole (a music school for children) located at the old military barracks in the Danish town of Ringsted.
→ www.malenehartmannrasmussen.com

Marc Andre Robinson, born in Los Angeles, earned an MFA in sculpture from the Maryland Institute College of Art in 2002. He participated in the Whitney Independent Study Program and was artist-in-residence at the Studio Museum in Harlem, the Lower Manhattan Cultural Council, and the Rocktower in Kingston, Jamaica. Robinson has exhibited in the U.S. and abroad at venues including the New Museum of Contemporary Art, New York; GAM, Torino, Italy; and the Centre for Contemporary Arts in Glasgow, Scotland. He currently lives and works in Brooklyn, New York, and is a professor of sculpture at SUNY Purchase.
→ www.marcandrerobinson.com

Rub Kandy is a Rome-based artist and graphic designer who works using different media. He often works using the city as layout of his research, exploring physical spaces and visual elements of our identity. He's fascinated by the aesthetic potential of the locations that are not made to host artworks. He finds his inspiration from the peripheries of the city, such as abandoned places or building sites where the environment is changing.
→ mimmorubino.com

Álvaro Sánchez-Montañés (born 1973) is a photographer born and raised in Madrid, where he lived until completing his university studies. He is currently living in Barcelona, where he has developed his photography career over several years. His work has been exhibited in Madrid, Barcelona, Seville, Bilbao, London, Paris, Mexico City, and New York, among other cities, achieving several awards and mentions, such as the Epson Photography Award 2009, Descubrimientos PhotoEspaña 2010, International Photo Award 2009, and Fundación AENA 2012. His work is present in numerous public and private collections.
→ www.alvarosh.es

Mary Sibande, born 1982, lives and works in Johannesburg. She obtained a B-Tech degree in fine arts at the University of Johannesburg in 2007. In Sibande's practice as an artist, she employs the human form as a vehicle through painting and sculpture, to explore the construction of identity in a postcolonial South African context, but also to attempt to critique stereotypical depictions of women, particularly black women in our society. The body, for Sibande, and particularly the skin, and clothing are the site where history is contested and where fantasies play out. Centrally, she looks at the generational disempowerment of black women, and in this sense her work is informed by postcolonial theory.
→ www.gallerymomo.com/artists/mary-sibande/

Berndnaut Smilde (born 1978, Groningen, Netherlands) lives and works in Amsterdam. Smilde's work consists of installations, sculptures, and photos. Using his daily surroundings and spaces as inspiration, Smilde is interested in the temporal nature of construction and deconstruction. Smilde holds an MA from the Frank Mohr Institute, Groningen. His work resides in both the Saatchi and the Smithsonian collections, among others. Selected exhibitions include Bonnefantenmuseum, Maastricht, Netherlands; Saatchi Gallery, London, U.K.; Juming Museum, Taipai, Taiwan; and Land of Tomorrow, Louisville, Kentucky. His *Nimbus* series was recognized by *TIME* Magazine as one of the Top Ten Inventions of 2012.
→ www.berndnaut.nl

Gerda Steiner (1967) and **Jörg Lenzlinger** (1964) have exhibited all over the world, including Australia, Japan, France, Denmark, Switzerland, and Germany. For more information, please visit their website.
→ www.steinerlenzlinger.ch

Swoon is a printmaker and street installation artist whose larger than life woodblock prints and cut-paper portraits can be found on walls in various states of beautiful decay in cities around the world. She is an international artist with major pieces in the Museum of Modern Art, PS1's groundbreaking exhibition *GREATER NEW YORK*, Brooklyn Museum of Art, Deitch Projects, and the Tate. Swoon has been traveling for the past several years creating exhibitions and workshops in the United States, Europe, Asia, and Africa.

Leonid Tishkov, born in 1953 into a schoolteacher's family in a small town in Russia's Ural Mountains, now lives and works in Moscow. He has participated in numerous

important group exhibitions, including Berlin-Moscow Moscow-Berlin 1950–2000, Berlin; Martin Gropius Bau (2002); Eye on Europe, 1960 to Now (MoMA, the Museum of Modern Art, 2006); Fabric of the Myth, Compton Verney Gallery, U.K. (2007); the Singapore Biennale (2008); and the Moscow Biennale (2009). His solo exhibitions include Nasher Museum of Duke University, Durham, North Carolina (1993); Museo de Arte Contemporeneo de Caracas Sofia Imber, Venezuela, (1995); Block Museum, Northwestern University, Evanston, Illinois (1996); Fargfabriken, Center for Contemporary Art, Stockholm, Sweden (1998); Center for Contemporary Art Uajzdowski castle, Warsaw, Poland (2007); Kaohsiung Museum of Fine Arts, Taiwan (2009); and the Moscow Museum of Modern Art (2010). Tishkov's poetic and metaphysic oeuvre is realized in a diverse and often unconventional range of media, including installations, sculpture, video, photography, works on paper, and books.
→ leonid-tishkov.blogspot.com

Michal Trpák was born in 1982 in what is now the Czech Republic. He began his art studies at Secondary School of Arts in Cesky Krumlov, and went on to earn an MA at the Academy of Arts and Design in Prague in 2007. After graduating, he started to work as an artist and completed a PhD at the Academy of Arts in Banska Bystrica-Slovakia. Since 2007, Trpák has been organizing a sculpture exhibition called ART in the city of Ceske Budejovice, where sculptors exhibit their works during the summer. Work by Michal Trpák appears both in public spaces and private collections in the Czech Republic, Germany, Russia, France, and Canada.
→ www.michaltrpak.com

Serena Garcia Dalla Venezia is a Chilean artist born in November 1988 in Venice, Italy. She studied visual arts and education in Santiago, Chile. She has created work in many media, such as drawing, collage, watercolors, and textiles. She has been creating textile works since 2010, including three-dimensional installations in architectural spaces and on dimensional canvases. She has participated in multiple solo and group exhibitions, and is involved in multiple art fairs in Santiago.
→ cargocollective.com/serenagarciadallavenezia

Phoebe Washburn was born in 1973 and received an MFA from the School of Visual Arts in New York. Washburn's installations have been the focus of solo exhibitions at Kunsthallen Brandts, Denmark (2013); National Academy Museum, New York (2012–13); kestner gesellschaft, Hannover, Germany (2009); Deutsche Guggenheim, Berlin (2007); Institute of Contemporary Art, Philadelphia (2007); and the UCLA Hammer Museum, Los Angeles (2005). She is the recipient of the Louis Comfort Tiffany Award (2009) and the American Academy of Arts and Letters Award (2005), and her work is represented in the permanent collections of the Hammer Museum at UCLA (Los Angeles), the Guggenheim Museum (New York), and the Whitney Museum of American Art (New York). Washburn lives and works in New York City.
→ www.zachfeuer.com/artists/phoebe-washburn

PHOTO CREDITS

Photo credits in alphabetical order of artist's name and order of captions.

Pages 12–13
© Adel Abdessemed, ADAGP Paris
Courtesy of the artist and David Zwirner, New York/London
Installation view of *Habibi* (2003) at the 2004 solo exhibition *Adel Abdessemed: Le Citron et le Lait* at the Musée d'art moderne et contemporain (MAMCO), Geneva, Switzerland

Pages 14–15
Images courtesy of the artist
Studio Shots

Pages 16–19
Euphony, Ball-Nogues Studio. Photos: Bruce Cain.
Principals in Charge: Benjamin Ball and Gaston Nogues
Project Manager: James Jones
Project Team: Caroline Duncan, Richy Garcia, Emma Helgerson, Christine-Forster Jones, Allison Myers, Mora Nabi, Adam Parkhurst, Bhumi Patel, Allison Porterfield, Marissa Ritchen
Custom Software Design: Pylon Technical
Structural Engineer: Buro Happold, Los Angeles. Frank Reppi lead engineer.

Pages 20–21
Courtesy of the artist. Photos: Trevor Good

Pages 22–23
Constructed with the neighborhood volunteers, as well as the friends of the St Nicks Alliance, Arts@Renaissance, and Round Robin Arts Collective.
2012 prismatic vortex is a fabric installation that was shown at Arts @ Renaissance in Brooklyn, N.Y., as part of the Round Robin residency. The installation was made with help from Ailsa Cavers, and fabric and sewing donated by people from the neighborhood.

Pages 24–27
Photos by James Prinz Photography. Courtesy of the artist and Jack Shainman Gallery, New York

Pages 28–29
The project was commissioned by Southern Exposure and funded by the Graue Family Foundation.

The cabin was craned into location and affixed to the side of Hotel Des Arts with 4 custom steel brackets. The cabin had a solar panel attached to the roof top. It collected energy during the day and lit the cabin at night with a warm comforting light.
Photo 1: Cesar Rubio / www.cesarrubio.com
Photo 2: Mark Reigelman / www.markreigelman.com

Pages 30–31
Miguel Chevalier. Alexis Veron, Forum des Halles, Paris. Generative virtual-reality installation
In collaboration with Trafik
Music: Michel Redolfi
Software: Cyrille Henry, Trafik
Technical coordination: Voxels Productions

Pages 32–33
All photographs and information courtesy of the artist, Michel de Broin.

Pages 34–35
Photos: Megan Cullen
Photos courtesy of Melbourne Water

Pages 36–37
Art Installation Suzan Drummen
Commissioned by Jola Cooney and Steve Brugge
Kunstcommissie SVB

Pages 38–41
The copyright to all photographs belongs to Alejandro Durán.

Pages 42–43
Photo 1 and 3: Janus van den Eijnden
Photo 2: Ben Visbeek

Pages 44–45
© Leandro Erlich Studio

Pages 46–49
Christine Finley. Wallpapered dumpsters.

Pages 50–51
Images courtesy of FriendsWithYou

Pages 52–53
Images courtesy of the artist, Joost Goudriaan

Pages 54–57
Photos by Thibault Jeanson. Commissioned by Park Avenue Armory. Courtesy of Ann Hamilton Studio

Pages 58–59
Courtesy of Lynne Harlow and Minus Space NY

Pages 60–61
Images courtesy HENSE and Miguel Martinez

Pages 62–67
Photo 5: © Trey Ratcliff
Images courtesy of Florentijn Hofman

Pages 68–71
Photographs taken by Patrick Sullivan

Pages 72–73
Photos by Christina Price Washington
Courtesy of Get This Gallery and Flux Projects

Pages 74–77
Photos © Institute For Figuring

Pages 78–79
Photos © Kaarina Kaikkonen

Pages 80–81
Installation photograph by Gijs van den Berg

Pages 82–83
Photos by Tetsuo Kondo Architects

Pages 84–85
Photos © Konoike, Tomoko.
Courtesy of the artist and Mizuma Art Gallery.
Photo 1: © Gallery Hyundai
Installation view "The Planet Is Covered by Silvery Sleep"
Mizuma Art Gallery/Tokyo 2006
Photo 2: Atsushi Nakamichi (Nacasa & Partners)

Pages 86–87
Photo 1: Ri Eung-woo
Photo 2: Cornelia Konrads

Pages 88–89
Photo 1: © R. Schmalschlaeger
Photo 2: © Joris Kuipers

Pages 90–91
Photo credit: © Hitoshi Kuriyama

Pages 92–93
Photo credit: Courtesy of William Lamson
Site specific installation for Storm King

Pages 94–95
Photos by Matthew C. Weedman
This project was made possible by the City of Denver and the Denver International Airport.

Pages 96–99
© Myoung Ho Lee, Courtesy Yossi Milo Gallery, New York

Pages 100–101
Collection of the artist.
Photo 1: Malcolm Smith
Photos 2 and 3: LILIENTHAL|ZAMORA

Mw [Moment Magnitude], organized by the Frye Art Museum and curated by Jo-Anne Birnie Danzker, Joshua Kohl, Ryan Mitchell, Doug Nufer, and Yoko Ott. The exhibition is funded by the Frye Foundation with the generous support of Frye Art Museum members and donors. Sponsored by Frank Stagen, Nitze-Stagen, and Riddell Williams, it is supported by the Washington State Arts Commission, with funding—in part—by The Wallace Foundation, and by 4Culture and the Seattle Office of Arts & Cultural Affairs. Seasonal support of the Frye Art Museum is provided by Canonicus Fund and ArtsFund. Media sponsorship is by KUOW 94.9FM and The Stranger. Opening-event sponsorship is by The Boeing Company.

Pages 102–103
Photos: James Ewing.
Commissioned by: Park Avenue Tunnel, NYC DOT "Summer Streets"

Pages 104–105
Photography: Masaki Koizumi Studio, Tokyo
Collaborators: Charles MacAdam with Interplay Design & Manufacturing, Inc., Nova Scotia, Canada (design and production)
Norihide Imagawa and T.I. S. & Partners, Co. Ltd, Tokyo (structural design)
Collection: The Hakone Open Air Museum

Pages 106–107, 175
Photos courtesy of Russell Maltz and Minus Space NY

Pages 108–109
Photography by Sandra Ciampone

Pages 110–111
Photo credit: Lyés Sidhoum, Lorenzetti Gallerie

Pages 112–113
Mademoiselle Maurice

Pages 114–117
Shelley Miller
Victoria, B.C., Canada. In conjunction with a residency at Open Space.